# FAERYLAND

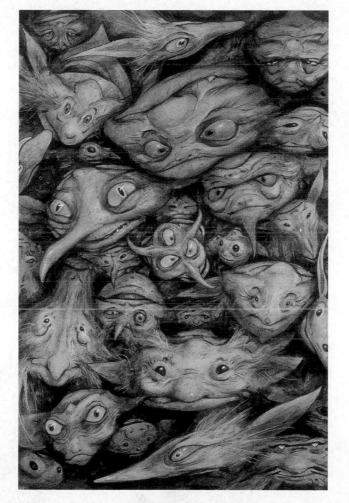

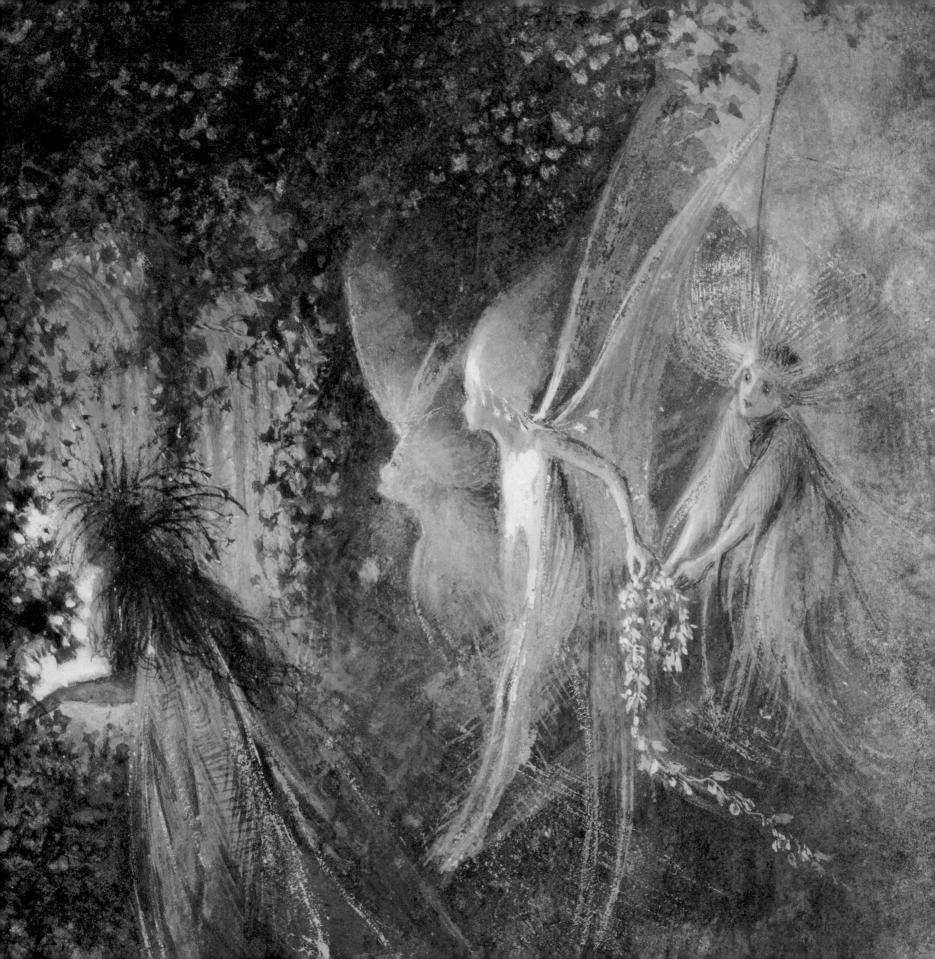

# FAERYLAND

## The Secret World
### of the
## Hidden Ones

by John Matthews

Specially commissioned art
by Matt Dangler

ABRAMS, NEW YORK

**FRONT COVER** Illustration by Matt Dangler (b. 1984).

**PAGE 1** *The Topsie Turvies*, by Brian Froud (b. 1947), captures the wildness and strangeness of the Unseelie Court.

**PAGE 2** *Fairies Looking Through a Gothic Arch*, by John Anster Fitzgerald (ca. 1823–1906). The artist was often called "Faerie" Fitzgerald, so widely known and loved were his paintings of the Hidden Ones.

**PAGE 6** *Haunted Faeryland*, by Matt Dangler.

**PAGE 8** Faeries often hide among waterways and trees.

Editor: Howard W. Reeves
Designer: Danielle Young
Production Manager: Alison Gervais

Library of Congress Cataloging-in-Publication Data:

Matthews, John, 1948–
   Faeryland : the secret world of the hidden ones / by John Matthews.
      p. cm.
   Includes bibliographical references.
   ISBN 978-1-4197-0673-8
   I. Title.
   GR549.M34 2013
   398.2—dc23
                    2012034653

Printed and bound in China
10 9 8 7 6 5 4 3 2 1

Abrams books are available at special discounts when purchased in quantity for premiums and promotions as well as fundraising or educational use. Special editions can also be created to specification. For details, contact specialsales@abramsbooks.com or the address below.

115 West 18th Street
New York, NY 10011
www.abramsbooks.com

To the memory of Peter Vansittart (1920–2008)
—J.M.

To my parents, for showing me "the way."
—M.D.

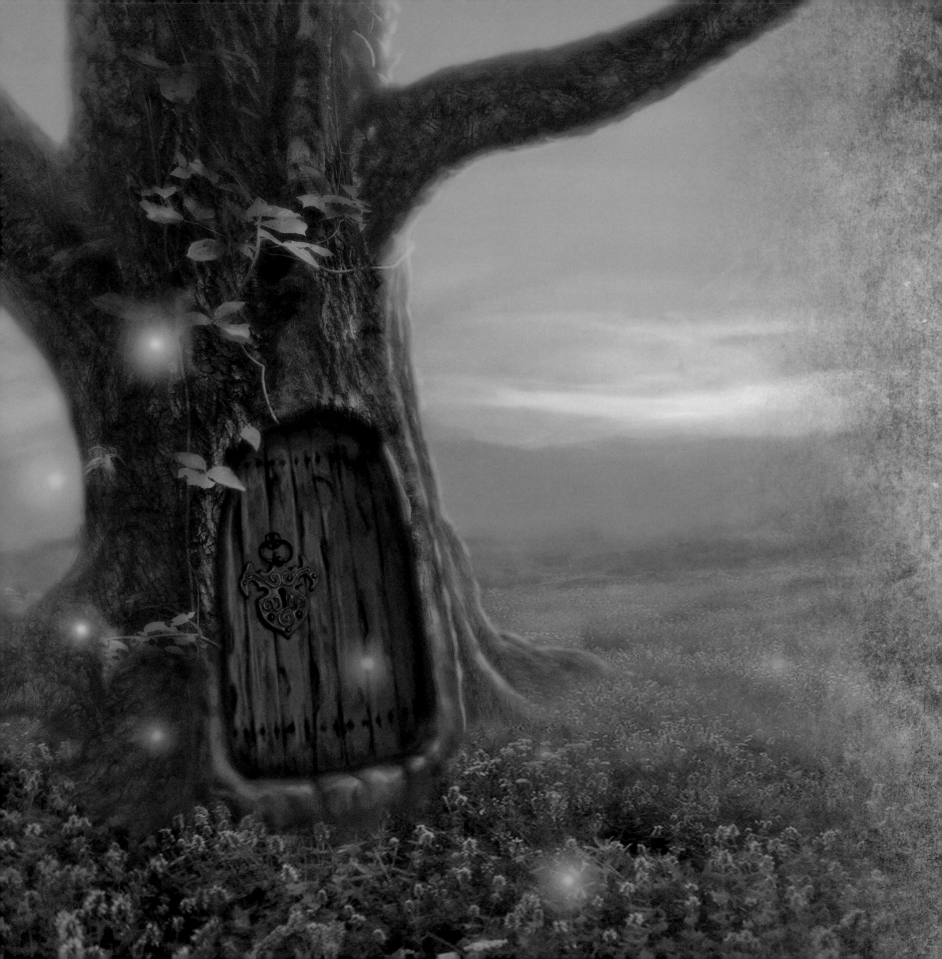

*The realm of fairy-story is wide and deep and high and*
*filled with many things: . . . seas and stars uncounted;*
*beauty that is enchantment, and an ever-present peril; both*
*joy and sorrow as sharp as swords. In that realm a man*
*may, perhaps, count himself fortunate to have wandered.*

—J. R. R. TOLKIEN "ON FAIRY-STORIES"

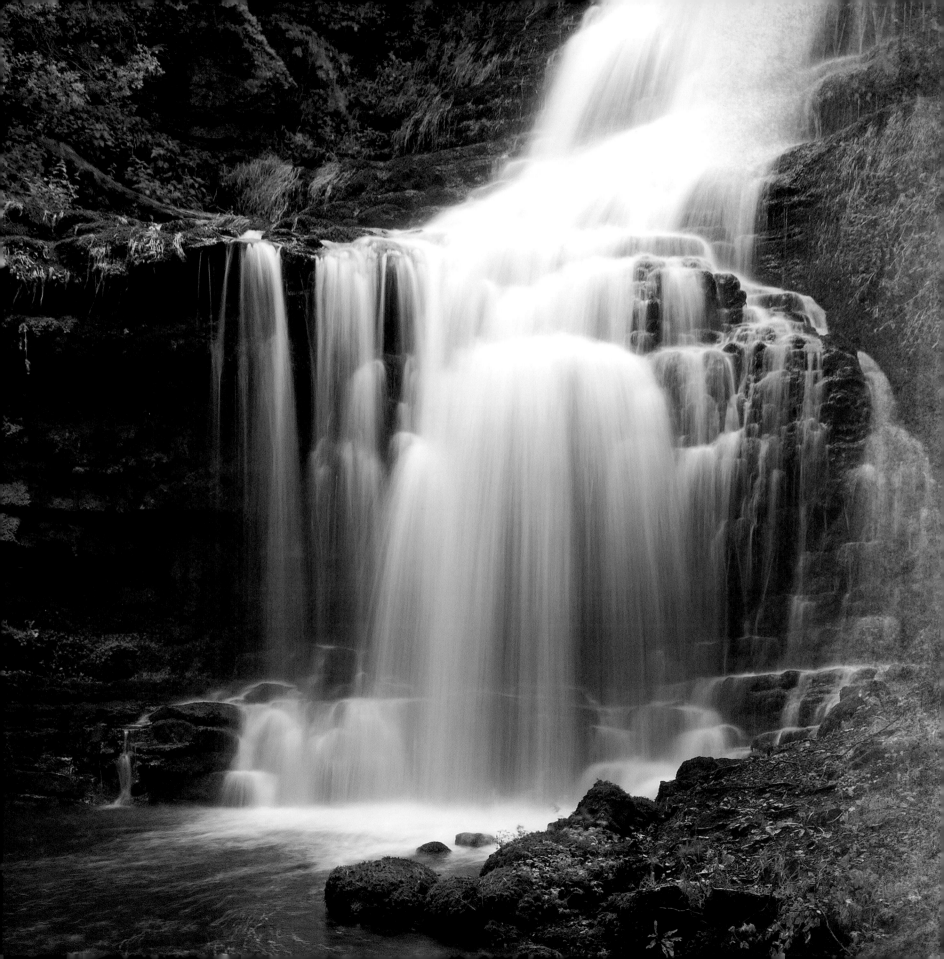

# CONTENTS

# ON FAERIES

THEY MOSTLY COME OUT AT TWILIGHT. A rustle under the hedge, a glimmer of light from the darkness beneath the trees, a whisper as dusk advances. Now you see them; now you don't. Faeries.

They can be kind or cruel, beautiful or ugly, large or small, noble or ignoble. They are mostly found in wild places— under trees or bushes, inside hills or beside streams. They are utterly unknowable, and they have many names: Peri, Tylwyth Teg, Elves, Pixies, Korrigans, Merrows, Djinn, the Sidhe. But they all fall within the realm of Faerie. And though most of the stories we know about them come from Europe and especially the British Isles, Faerie sightings are reported in Africa, Arabia, New Zealand, and North America.

Most people, if asked, would probably describe Faeries as tiny winged creatures with the power to change shape and grant wishes. But this is mostly a Victorian view, and there is a great deal more to them than that.

Real Faeries are seldom friendly. They can carry off human children and replace them with their own changelings—pale and wizened like weathered apples. Or, if they catch human beings trying to steal some of their fabulous riches, or just spying on them, Faeries can respond with severe punishments: blindness, seizures, the inability to stop dancing. Sometimes they can even bring death to the watchers. Thus, they teach us not to be curious, and we learn to never, ever interfere in their secretive activities. But Faeries never stop being a source of fascination, of wonder, of mystery and magic.

It has never been safe to go into the Otherworld of Faerie. If you are unfortunate enough to stray into it (or fortunate, depending on how you look at it), you have to be careful. If you eat their food or drink their water, you can find yourself stuck there for a thousand years—during which time you will grow no older. Yet, if and when you do find your way back into this world, you will very likely turn into the dust of ages the moment your feet touch the earth.

Faeries are often glamorous. In fact, *glamour,* our modern word for the allure of a beautiful person, comes from an older word for a spell cast upon a mortal so that he or she

10

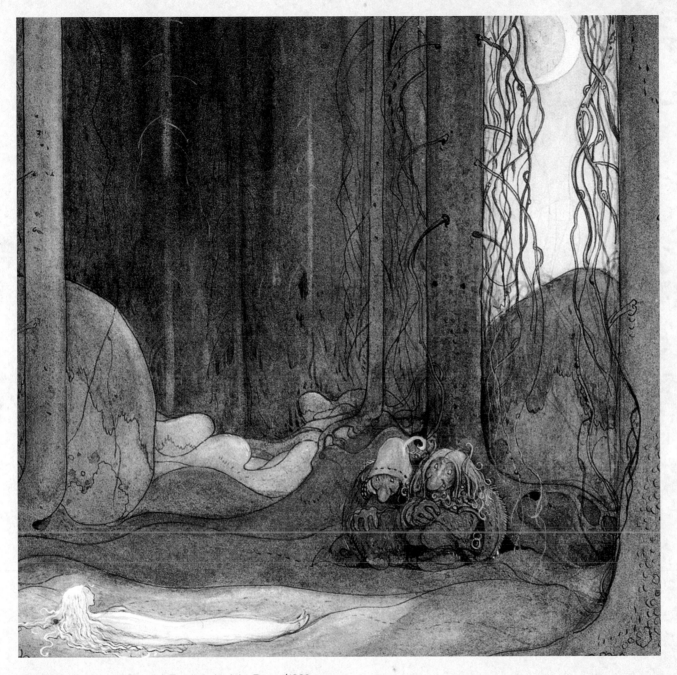

*The Changeling*, by the Swedish Faerie artist John Bauer (1882–1918), shows trolls watching over the gleaming body of a human child they have stolen.

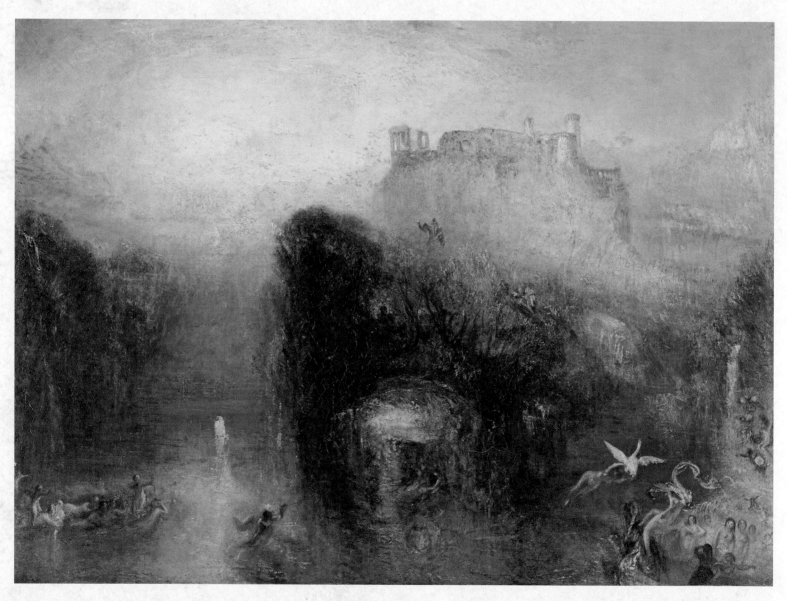

**ABOVE** *Queen Mab's Cave*, by J. M. W. Turner (1775–1851). This dreamlike painting captures the mystery and strangeness that surrounds places where Faerie beings dwell.

**OPPOSITE** Sophie Anderson (1823–1903) painted this enchanting image of a Faerie in the wonderfully titled *Take the Fair Face of Woman, and Gently Suspending, With Butterflies, Flowers, and Jewels Attending, Thus Your Fairy is Made of Most Beautiful Things.*

will be irresistibly drawn to a Faerie, like a moth to a flame. In the Scottish story of Tam Lin, a young man falls in love with the queen of Faeries and becomes her slave, unable to escape for many years. He is held captive until a mortal girl loves him and wins him back by undergoing terrible tests in which she must hold on to him as he shapeshifts from human to animal, fish, and red-hot iron.

Iron itself has always been inimical to Faeries, perhaps because their origin lay in a time before iron was forged by man. It is said that if you possess something made of iron about your person, no Faerie can touch you and you may even be able to enter and leave the Otherworld unhindered.

Ultimately, Faeries are mysterious and almost synonymous with the word. It's safe to say they are a very old race—older than we humans are. Some people think that Faeries are an ancient memory of a race that once lived on the surface of

Earth thousands of years ago, but were driven underground by invaders from across the seas. This is why we hear about their living in caves or vast mazes of tunnels, where mortals go at their peril.

Others will tell you the Faeries are the old, pagan gods of the earth and sky, who diminished as other beliefs overcame them, who lost their original power as they were remembered less and less with the passage of time. This may account for their unwillingness to be seen, and their power to grant wishes or change their form (or ours) at will. Still others say that Faeries are fallen angels, cast out of heaven for rebelling against God or for dancing on a Sunday.

Nobody quite agrees about Faeries, the hidden ones; and perhaps that's just as well. A world without them would be a sadder, colder place. Think of Peter Pan's famous question, asked in countless theaters of countless children, there to see J. M. Barrie's great play: *Do you believe in Faeries?* The answer, shouted back from generations of children, is always: *Yes!* And that's how it should be; and not only for children. Faeries enrich our lives with magic and the lure of the unknown; everyone should believe in them!

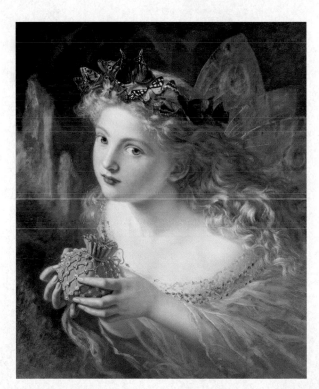

The origin of the word *Faerie* (*Fairy, Fayerye, Fairie*) probably comes from the Latin word for fate, *fata*. In English this became *fay*, and in French, *fée,* or *féerie*; and in Spanish, *hada*. In ancient times, the Fates were personified as powerful beings in their own right. The association of fate with *Faerie* probably accounts for the way Faeries are believed to have power over the future of mortals.

# A WHO'S WHO OF FAERIE BEINGS

THE COURTS OF FAERIE ARE FILLED WITH wonderful characters. Some are graced with personal names; others are simply called by generic titles, such as Brownie, Hob, or Fachan; which tell you the kind of Faerie they are. Many Faeries do not wish you to know their true names. Such knowledge can give power to the one who knows how to wield it. Here are just a few of the inhabitants of the Faerie world.

## Oberon

The Faerie king is said to be the son of no lesser person than the Roman Emperor Julius Caesar and a Faerie woman called the Lady of the Secret Isle, which may well be the enchanted realm of Avalon since Oberon carries a magic bow made by the Faeries of that place. Oberon, by name, first appears in a medieval French romance about a knight known as Huon de Bordeaux. In the French story, the Faerie is much older. He has great powers over nature and can conjure storms and make rivers flow upstream. If anyone enters the hidden wood over which he rules, he speaks to them. If they answer, they are lost forever to roam his secret world, and if they fail to reply they are troubled by storms and shrieking voices in their ears.

Faeries are always tricky.

## Titania

Shakespeare called the queen of the Faeries by this name, which is thought to come from the name of the Roman goddess Diana. Proud and willful, but also glorious and regal, Titania still retains aspects of the goddess. Titania commands a court whose members bear colorful names: Mustardseed, Peasblossom, Cobweb. Shakespeare's knowledge of folklore was extensive, and there are threads of Faerie magic through many of his plays. As a countryman born, he knew the old tales of Faeries in woodlands and streams, but he gave the traditional stories a sophisticated, poetic twist that was uniquely his own.

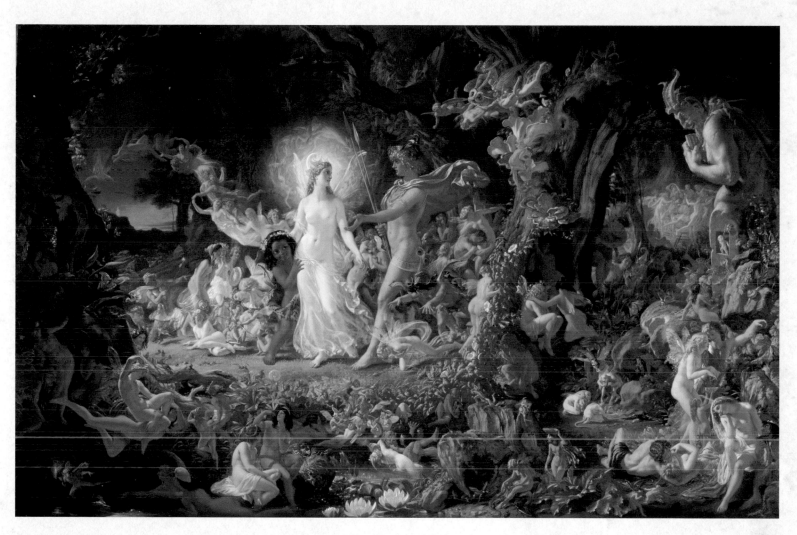

*The Quarrel of Oberon and Titania*, by Joseph Noel Paton (1821–1901),
is thronged with magical beings, typical of the Faerie court.

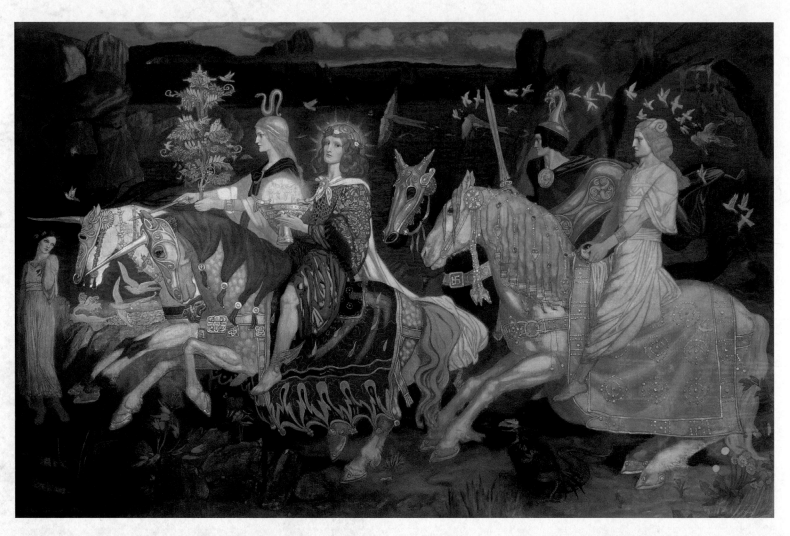

**ABOVE** *The Riders of the Sidhe*, by the Scottish artist John Duncan (1866–1945), perfectly captures the unearthly pride and beauty of the Sidhe, with their flowing hair and marble-white skin.

**OPPOSITE** Henry Fuseli's (1741–1825) portrait of Queen Mab shows the Faerie queen indulging in her favorite food—junket, a dessert made from milk and rennet sweetened with honey. She is surrounded by a strange gallery of Faerie attendants.

## The Tuatha Dé Danann

*Tuatha* means "tribe," and the Medieval Irish phrase means the "people of the goddess Danu." These are the lords and ladies of the Faeries. Tall, shining, powerful and fierce—they are the direct opposite of the tinsel-winged creatures beloved of the Victorians, and more recently of Walt Disney. Though they have other names, this one, which originated in Ireland, remains the one by which they are best represented.

> ## A FAIRY SONG
>
> Over hill, over dale,
> Thorough bush, thorough brier,
> Over park, over pale,
> Thorough flood, thorough fire!
> I do wander everywhere,
> Swifter than the moon's sphere;
> And I serve the Fairy Queen,
> To dew her orbs upon the green;
> The cowslips tall her pensioners be;
> In their gold coats spots you see;
> Those be rubies, fairy favors;
> In those freckles live their savors;
> I must go seek some dewdrops here,
> And hang a pearl in every cowslip's ear.
>
> —WILLIAM SHAKESPEARE

## Mab

This is one of several names given to the Faerie queen and is mentioned by Shakespeare. She rules over a race of tiny Faeries and is no bigger than they. In Welsh Faerie lore she is said to be very warlike, and she instructs her courtiers to steal human children; to raid farms for milk, corn and eggs; and to cause mayhem wherever they can. Shakespeare calls her the Faeries' "midwife," who comes to women in labor and delivers their children, then steals the newborns away and replaces them with changelings. She also sends fantastic dreams to haunt sleeping humans. The Romantic poet Percy Bysshe Shelley wrote a poem about Mab.

> I am the Fairy Mab: to me 'tis given
> The wonders of the human world to keep;
> The secrets of the immeasurable past,
> In the unfailing consciences of men
>
> —PERCY BYSSHE SHELLEY

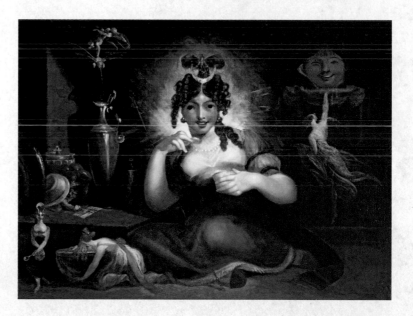

# THE ORIGINAL BALLAD OF
# THE MERRY DEEDS OF ROBIN GOODFELLOW

From Oberon in fairyland,
the king of ghosts and shadows there,
Mad Robin I, at his command,
am sent to view the night sports here:
What revel rout
Is kept about,
In every corner where I go,
I will o'er see,
And merry be,
And make good sport with ho, ho, ho!

More swift than lightening can I fly,
and round about this airy welkin soon,
And, in a minute's space, descry
each thing that's done beneath the moon;
There's not a hag
Nor ghost shall wag,
Nor cry "goblin!" where I do go,
But Robin I
Their feats will spy,
And fear them home with ho, ho, ho!

If any wanderers I meet
that from their night-sports do trudge home,
With counterfeiting voice I greet
and cause them on with me to roam,
Through woods, through lakes,
Through bogs, through brakes, —

O'r bush and brier with them I go;
I call upon
Them to come on,
And wend me, laughing ho, ho, ho!

Sometimes I meet them like a man;
sometimes an ox, sometimes a hound;
And to a horse I turn me can,
to trip and trot about them round.
But if to ride
My back they stride,
More swift than wind away I go;
Ore hedge and lands,
Through pools and ponds,
I whirl, laughing, ho, ho, ho!

When lads and lasses merry be
With possets and with junkets fine,
Unseen of all the company,
I eat their cakes and sip their wine;
And to make sport,
I fart and snort,
And out the candles I do blow;
The maids I kiss,
They shriek, "Who's this?"
I answer naught, but ho, ho, ho!

—ADAPTED FROM THE ROXBURGHE COLLECTION

## Fenoderee

Once one of the Ferrishyn, the Faeries of the Isle of Man, the Fenoderee was banished after he fell in love with a lovely mortal girl. He lived with her until her death, after which the lonely Faerie often worked on farms for the sake of human company. He seems never to have returned to the Otherworld, banished from it by all too mortal longings.

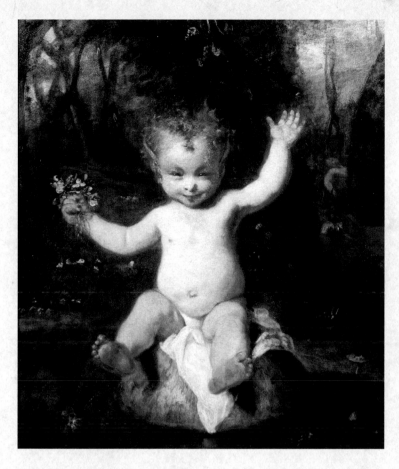

Puck is portrayed as a cherubic child with a face full of mischief and wildness in this image by Joshua Reynolds (1723–1792).

The strange, sad Faerie known as the Fenoderee, pictured here by Matt Dangler.

## Puck

Puck is, perhaps, the trickiest of all the Faeries whom we know by name. Also known as Robin Goodfellow, Puck delights in playing tricks on mortals, leading them astray at night so that they fall into bogs or deep pools. Believed to be the child of Oberon, he seems always to be reprieved from the kind of punishments normally handed out to naughty children. His cry of "ho, ho, ho!" rings like that of Santa Claus, the good Faerie of Christmas.

## Spriggans

Sometimes said to be the ghosts of old giants, despite their small size, these are a very different class of Faeries from the rest. Where most Faeries are beautiful or glorious, these supernatural beings are dark and ugly and of a morose temper. Found around old ruins, hollows or caves in hillsides—the places where treasure is stored—they guard their gold furiously, sending away anyone foolish enough to come close with a box on the ear—or worse. If roused to anger, they will blight crops by racing through the fields with flails of bone that leave great wounds in the earth.

## Selkies, Merrows and Undines

These are the Faeries of the sea: farmers of kelp and coral. Selkies are the seal people of Northern Europe. They live beneath the waves but come ashore from time to time, leaving their shining skins hidden in the sand dunes or under a bush

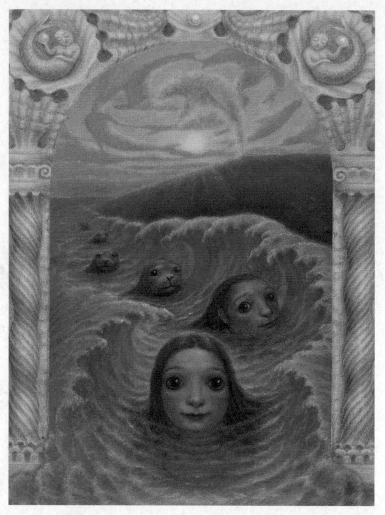

The mysterious Selkies, part human, part seal, transform in the water in this vibrant picture by Virginia Lee (b. 1976).

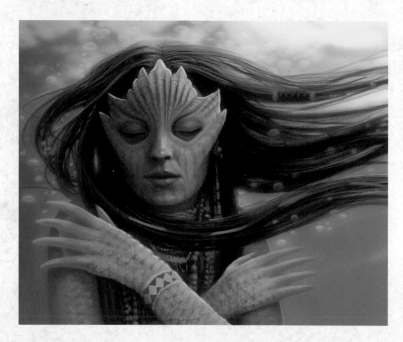

A North American Undine in a painting by Matt Dangler.

while they walk the land on two legs. There are frequent tales of humans marrying seal women (never the men, it seems, as the men are more cautious and hard to even glimpse). Most often, the marriages end in disaster, when either the call of the sea grows too strong, or the husband discovers the seal-skin and realizes he has married a Selkie.

Merrows are the Faerie equivalent of mermaids. They have fishtails and webbed fingers, and their eyes are just a little too large to be human. In Ireland, they are much feared because they usually appear before a storm or disaster at sea. Their male equivalents are said to be as ugly as the females are beautiful—with green faces, green hair, sharp red noses and tiny eyes like those of pigs.

Undines are water Faeries, who dance in waterfalls of fast-flowing rivers. They seek to capture handsome men and bear children by them. Wild and beautiful, they personify the most dangerous aspect of the Faerie kind: their seductive and glamorous nature, which is hard for a human to resist.

The Micmac people of Eastern Canada tell how a young man married a beautiful water Faerie. She was given to him after he captured her older sister and released her only in return for a bride. The pair had children and visited the kingdom of her father, the chieftain of the land under the water. When chased by a hungry shark, the Faerie placed their child in her husband's hands and lured the creature away. The tale does not reveal if she survived.

## Peri and Devs

The fire Faeries of Persia are formed of the element itself. To live, they consume perfume and other exquisite odors and are said to be more beautiful than the sun and moon. The bad Faeries of Persia, called the Devs, are forever at war with the Peri. The Devs like to hang Peri in iron cages from the highest trees.

In a Persian story, a merchant observes Peri bathing in a stream. He hides their magical clothing, and when they emerge says he will only return the clothing if one of the Peri agrees to marry him. Though they protest that creatures of fire and air cannot marry mortals of clay, one at last agrees. In time, the Peri becomes genuinely fond of the merchant, bearing him three children. But after ten years,

he has to make a long journey, and he leaves his wife in the care of a serving woman. Before leaving, he reveals the truth about his beautiful wife and even where he has hidden her Faerie raiment. Once the man is gone, it is not long before the servant is tricked into revealing the whereabouts of the

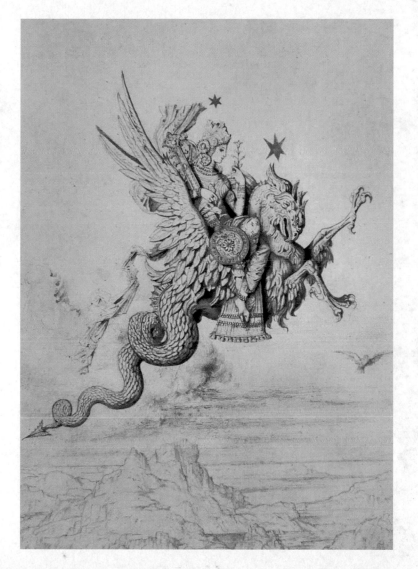

A beautiful Peri takes to the air on the back of an exotic beast in this drawing by French artist Gustave Moreau (1826–1898).

hidden garments, and once the Peri has donned them she flies away, never to be seen again. The merchant mourns his loss till the end of his days, but the descendants of the man and the Peri are more handsome than others and their line is long-lived.

## Djinn

These are the Faeries of Arab tradition, widely known throughout most of the Islamic world, especially the Sahara and the northern and eastern parts of the Mediterranean. Most are portrayed as unfriendly. Though some are helpful,

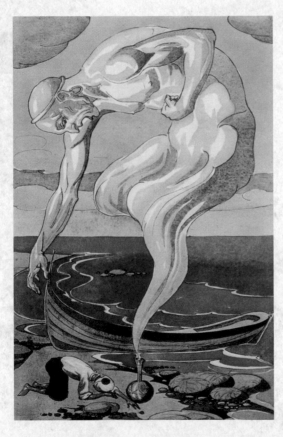

A Djinni is released from a magic bottle in which it has been imprisoned for countless ages in this illustration from an early twentieth-century German translation of *One Thousand and One Arabian Nights*.

such as the Genie of the Lamp in the folktales about Aladdin, the majority are very ugly and savage in nature. They can take numerous shapes and have been known to appear as human beings, monsters, cats, ostriches, dogs and snakes. When they do take human form, it is often that of a beautiful woman, who may only be detected by the fact that the pupils of her eyes have vertical slits like a snake. Djinn, or Jinn, cause sandstorms and waterspouts, and for this reason the *Zoba'ah*, a whirlwind that forms itself into a pillar of sand stretching to enormous heights, is believed to be caused by the flight of a Djinni. Almost the only defense against these Faeries is iron, as in the traditions of European Faeries, and any iron object can bind them. According to Koranic tradition, the Djinn were created from fire and have fire in their veins instead of blood. Djinn dwell in drains, toilets, cemeteries and dark damp ruins.

## Abatwa and the Tokolosh

The Faerie kin of South Africa are the Abatwa. Tiny creatures, they live peacefully alongside ants, foraging for roots and grasses. They are very shy and elusive but will at times reveal themselves to very young children, wizards or pregnant women.

Also found in South Africa is the Tokolosh, who lives next to streams and can be seen throwing stones into the water on still evenings. He is described as being something like a baboon, but smaller and without a tail. He has an elongated face, like that of a tree trunk. He is often covered with black hair and is famous for frightening lone travelers.

## Asparas

Beautiful Faerie-like beings of Hindu and Buddhist cultures, the Asparas are also known as Sky Dancers. They bring good luck and plenty to fortunate humans and are often seen at weddings. They can change shape at will and often live

in water. In some stories, they inhabit the spirit realm and dance before Lord Indra, king of the Hindu gods. As with most Faerie beings, they can change the fate of any human at will.

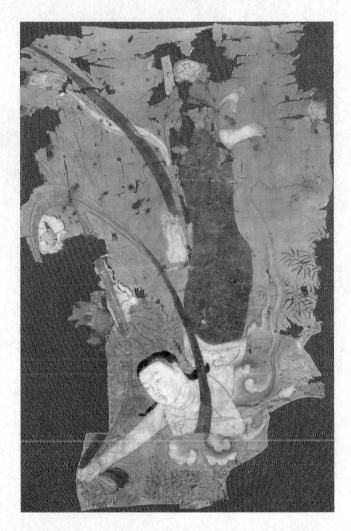

ABOVE A dazzling Aspara flies down from the world of Faerie in this painting on silk from Dunhuang, in Gansu Province, China (ca. ninth to tenth centuries).

FOLLOWING SPREAD The Abatwa, astride his steed, and the Tokolosh are not friends, as we see in this painting by Matt Dangler. The Abatwa interrupts the Tokolosh's mischief, only to be met by a thrown stone.

## SPELL TO SUMMON A FAERIE

Elias Ashmole (1617 1692), the renowned Oxford scholar, compiled a collection of Faerie spells, collected from older writings and from people who knew the words to be said.

*Cut a wand of three hand-lengths from a year-old ash tree and peel it till it is white.*

*Then write upon it the name of the Faerie you wish to call*

*and bury it on a hillside where it is known that Faeries do come,*

*all the while calling out the name of the Faerie— no more than eight times.*

*Do this on the Wednesday before you call the Faerie,*

*and then on the Friday go and dig up the wand*

*at eight in the morning or three in the afternoon or ten at night—*

*these all being excellent times to call Faeries.*

*When you call see that you are facing the East.*

*Do this and you shall see a Faerie.*

—ADAPTED FROM A SPELL IN THE MANUSCRIPT COLLECTION OF ELIAS ASHMOLE

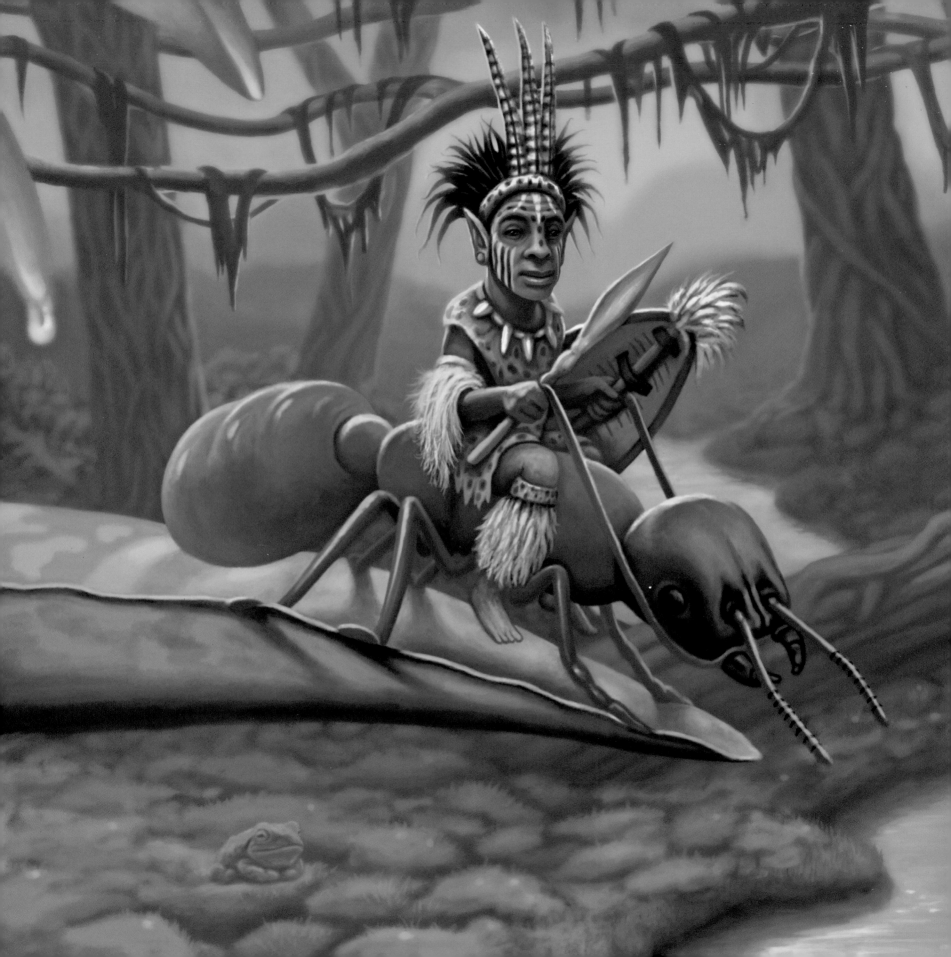

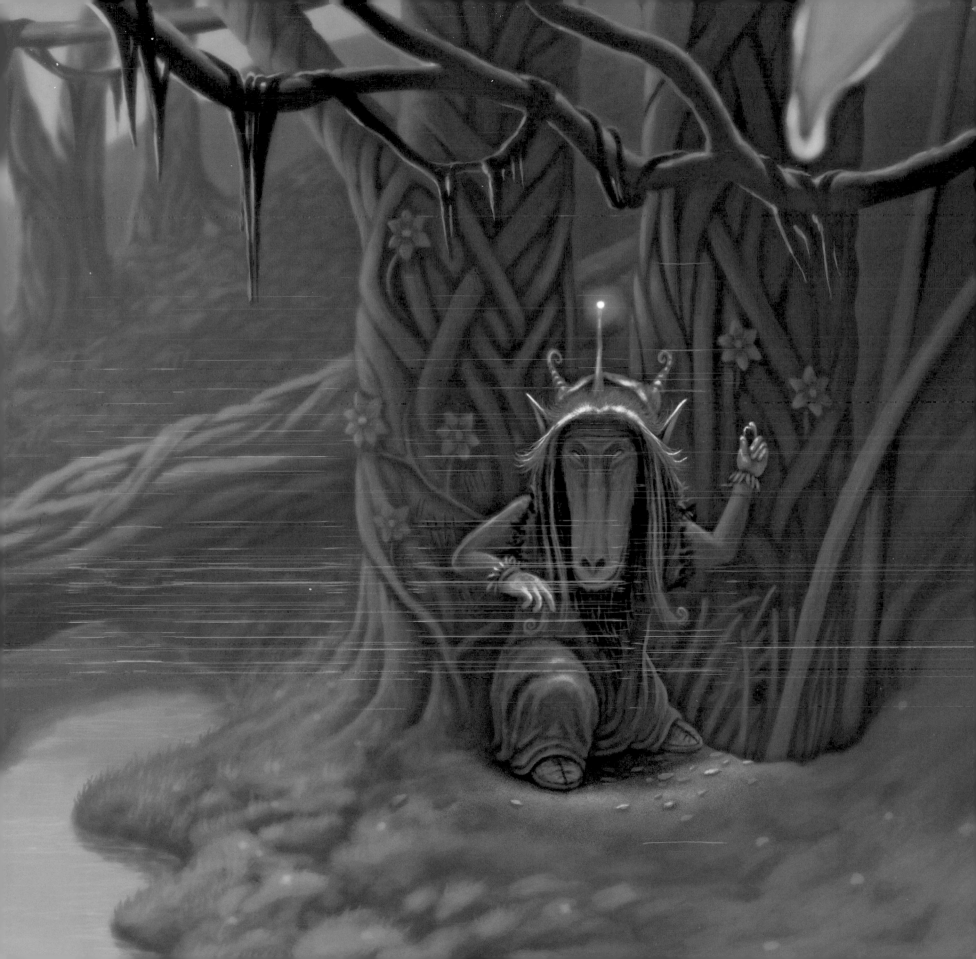

# FAERIE COURTS

*All was this land full filled of faerie.*
*The elf-queen, with her joyous company,*
*Danced full oft in many a green mead*

—ADAPTED FROM GEOFFREY
   CHAUCER'S "THE WIFE OF BATH'S TALE"

JUST AS THERE ARE good and bad humans, so there are good and bad Faeries. The bad Faeries are not always evil creatures but dangerous tricksters and malevolent sprites whose greatest pleasure is to lead humans astray into bogs, or imprison them in caverns below the earth. So distinct are these types of Faeries from the more friendly, helpful kind

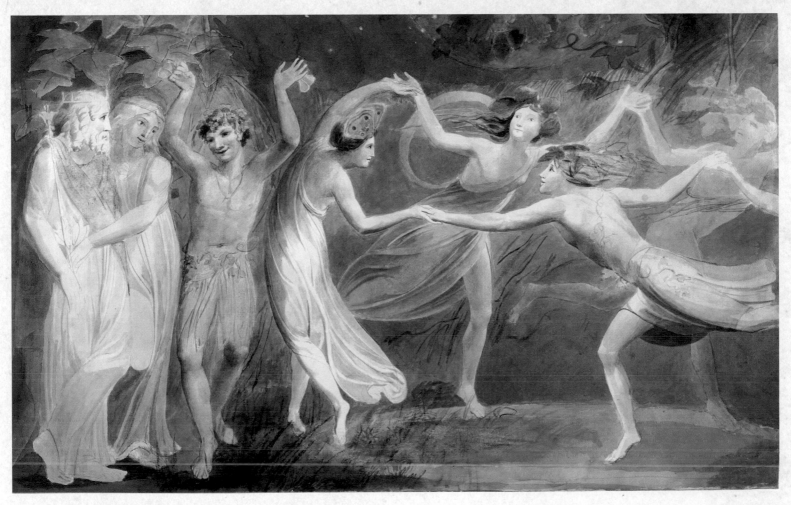

The visionary artist William Blake (1757–1827) offered his own images of the Faerie race. This picture gets closer to the true appearance of the Fairie than most.

that they have been divided into two courts named—in words borrowed from the Gaelic—*Seelie* (the Blessed Faeries) and *Unseelie* (the Unblessed Faeries). If you meet the Seelie Faeries, you might get a wish granted; but if you encounter the Unseelie you may not survive! You may ask how you can tell them apart. To which the best answer is: they may look the same, but they "feel" different.

But there is more to it than this, as there is always more where Faeries are concerned. The race is always contrary, never quite what we expect it to be; and the one thing that most writers on the subject agree upon is that Faeries are *perilous*. This is born out in countless tales of Faeries who offer help to mortals but attach a price tag to the deal. On the whole, you never know what kind of experience you are going to have when you encounter Faeries. It's probably best to be prepared for anything.

# FAERIE NAMES

HERE ARE SOME OF THE NAMES, both generic and individual, given to Faeries around the world.

### Africa
Abatwa
Moohal
Tokolosh

### Arabia
Djinn
Peri

### Cornwall
The Old People
Pixies, or Piskies

### England
Fae, or Fay
Farisees, or Pharisees
Fary Gabriel
Feriers, or Ferishers
Frairies
Greencoaties
Greenies
Ratchets

### France
Fée

### Germany
Kobolds
Lios Alfar
Swart Alfar

### India
Asparas
Gandharva

### Isle of Man
Ferrishyn
Li'l Fellas Sleigh Beggey
Themselves, or They or Them that's in it

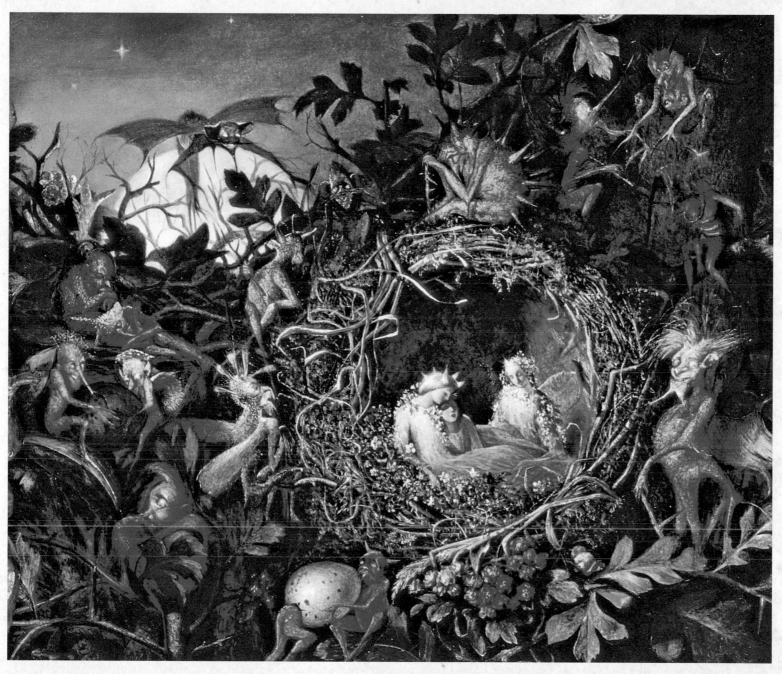

In his picture *Fairies in a Bird's Nest*, John Anster Fitzgerald captures
the strangeness of many of the beings that live in Faeryland.

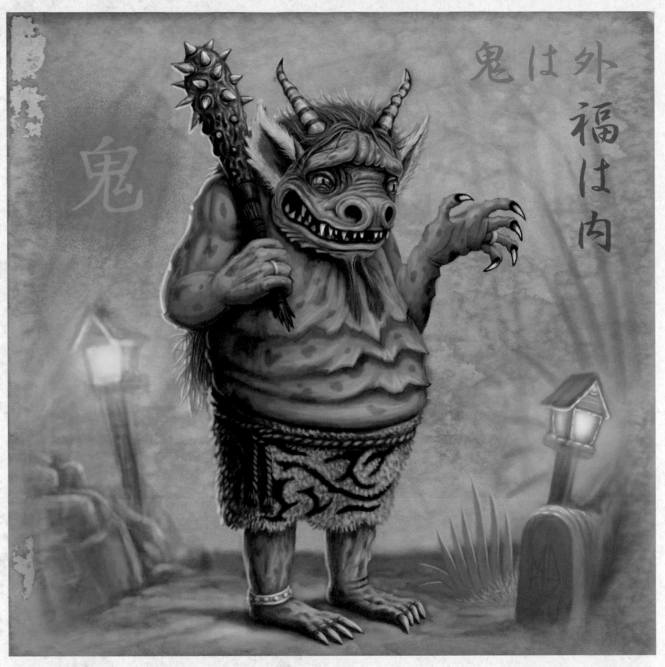

鬼は外福は内

Oni, a Japanese Faerie, is a fearsome, invincible being that is usually depicted carrying an iron club called a *kanabō*, as seen in this painting by Matt Dangler.

30

## Japan
Oni

## Russia
Vilas

## Scotland and Ireland
Good Neighbors
Good People
Grey Neighbors
Henkies
Klippe
Pooka
Sidhe "The People of Peace"
Sith, or Si
Still-Folk
Trows

## Wales
Bendith y Mamau
Fair Family, or Fair Folk
Tylwyth Teg
Verry Volk

## The Many Names of the Celtic Faerie lands

Nowhere in the world are there as many names for the homes of the Faerie races as in places occupied by the Celtic peoples. Here is a list, by no means complete, of the many realms of Faerie.

Annwn, or Annwfyn
Ioruatha
The Fortunate Islands
The Many Coloured Land
Tir nan Og (Land of the Young)
Tir fo Thuinn (Land Under Waves)
Tir nan Beo (Land of the Living)
Tir nan Ailill (Other World)
Tir Tairngire (Land of Promise)
Domnall's Land
Falias
Findias
Gorias
Isle of Grief
Isle of Scathach
Isle of Strong Men
Isles of the Blest
Lochlann
Mag Mor (Great Plain)
Mag Mell (Pleasant Plain)
Murias
Paradise of Birds
Uaimh Bodhbd (The Cave of Bodhbd)

# FAERIE PLACES

*While the faeries dance in a place apart,*
*Shaking their milk-white feet in a ring*

—W. B. YEATS, *THE LAND OF HEART'S DESIRE*

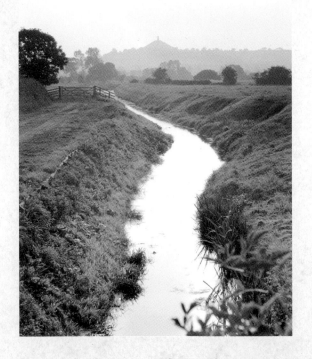

PEOPLE HAVE DESCRIBED ENCOUNTERS WITH Faeries for hundreds upon hundreds of years. There are countless places where Faeries have been sighted. Most are hidden, private domains where the Faeries can dance and play without being watched by humans. Most encounters happen on lonely roadsides, or when crossing hills or empty fields by the light of the moon. Such locations can usually be identified by their names: the Faerie Well, the Faerie Hill, the Faerie Pool, the Faerie Stone.

Some places where Faerie encounters have taken place can be located on maps. On Glastonbury Tor, in Somerset, England, the seventh-century Saint Collen encountered Gwyn ap Nudd, a fearsome lord of Faeries, and was taken below the hill to visit his court. Everything was splendid and golden,

32

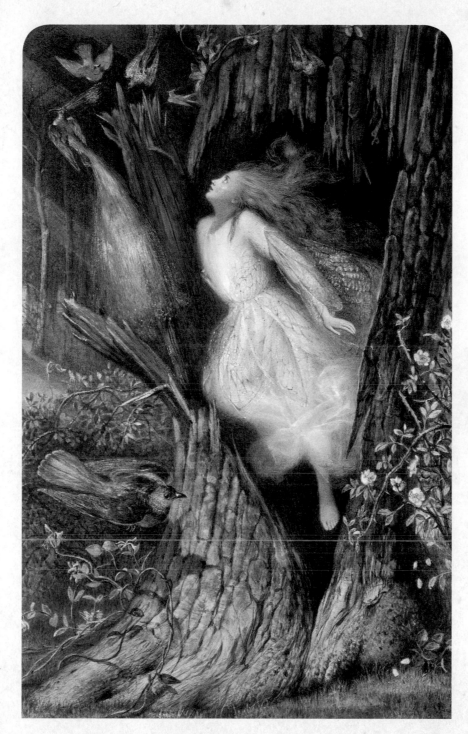

OPPOSITE The Faerie-haunted Glastonbury Tor rises in the distance above the Somerset plain.

RIGHT In *The Release of Ariel* by John Anster Fitzgerald, a spirit of the air, Ariel, emerges from a tree where she was entrapped.

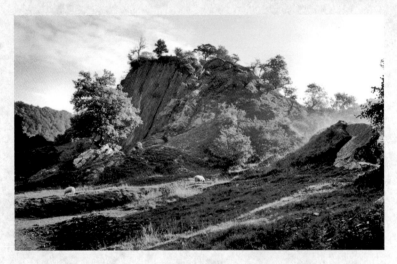

TOP This woodland is near Aberfoyle, where the Reverend Robert Kirk was taken into the Faerie realm.

BOTTOM Craig y Ddinas, Wales, is known as one of the entrances to Faeryland.

and Collen was offered a rich repast. But the saint believed the Faeries were demons, and he threw holy water at them. Instantly, he found himself transported back outside.

One of the most intriguing stories involving Faeries took place at the Faerie hill near Aberfoyle in Stirling, Scotland.

A local vicar, the Reverend Robert Kirk, wrote a book about Faeries in which he described them so vividly that it was widely believed he had visited them. On May 14, 1692, Kirk vanished, never to be seen again. It was assumed he had died, and a grave was erected in the Aberfoyle churchyard. But afterward the grave was opened and found to be empty, and Kirk's cousin claimed to have seen him, and to have been told that he lived in Faeryland.

In Wales, the hill Dinas Emrys, where the famous magician Merlin uttered his first prophecies, is also associated with Faeries. They have been seen appearing and disappearing through a door in the side of the hill on the always magical nights of May Eve and Midsummer Night. The same story is told about another Welsh hill, Craig y Ddinas, which has long been described as a Faerie fortress. It is said that if one can get into the hill one will come back with a great fortune, but so far no one has admitted to getting in—or out—of this particular Faerie place, and if anyone has succeeded in getting hands on any treasure, no one has owned up to it yet!

In Ireland, it is often said that there are so many Faeries that you can find one under every bush or behind every tree in the country. Around Loch Gur and Knockadoon in County Limerick, hundreds of sightings have been reported; while Connaught has an entrance to Faeryland through which local people have entered and, at least some of them, exited for ages.

Outside the British Isles, people tell stories of Elf roads and Elf barrows, along which the Faeries travel at night in large companies and in which they dwell between times. These are possibly ancient gravesites. In Denmark, there are Elf barrows near Galtebjerg and near Kalundborg; there is one between Thisted and another at Aalborg that was said to be the home of an Elfin smith; and one at Trøstrup where, according to legend, a Faerie giant was buried. In Germany,

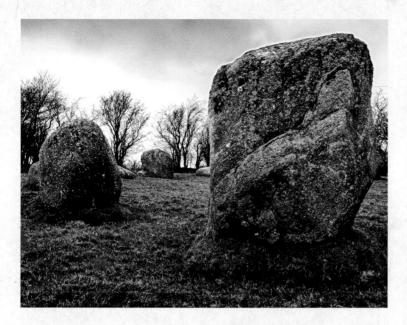

This stone circle in Athgreany, Ireland, known as Piper's Stones, is believed to be made up of Faeries turned to stone for dancing on Sunday.

Thorn trees are sacred to Faeries, and twisted trees are especially potent. It is extremely unlucky for anyone to fell a Faerie thorn. Many stories tell of the resulting chaos and ill luck that come to anyone brave enough to set an ax to one.

the Wild Troop of Rodenstein (a variant of the Famous Wild Hunt of England, in which Faeries ride in search of human souls) gallops along a straight path between the castles of Rodenstein and Schnellert, while the Mönchen Mountains are famous for their Faerie sightings. Throughout Europe are the corpse roads, which are associated with Faerie paths. In Germany and the Netherlands, these straight, invisible lines are known as *Geisterweg,* which means "Ghost Ways" or "Ghost Roads," while in Holland they are *Doodweg,* "Death Ways" or "Death Roads," adding a more sinister aspect to the Faerie traditions. It is, as ever, unwise to interfere with or block these roads. To do so brings swift retribution in the form of bad luck, which may last for several generations.

In Newfoundland, Canada, there are strong Faerie traditions, perhaps carried there by settlers from the Old World. Most often we hear of berry pickers led astray into the depths of the wilderness. People have reported being "Faerie led," or finding themselves transported from one place to another without any memory of getting there. Sightings, usually of Little Folk, are frequent, as are stories of stolen children.

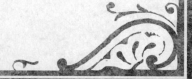

# FAERIE SIGHTINGS

OVER THE YEARS, MANY PEOPLE have claimed to see Faeries. Famous writers, such as John Milton, George "AE" Russell, Algernon Blackwood, Sir Arthur Conan Doyle, Fiona MacLeod (William Sharp) and W. B. Yeats, all wrote of their encounters. Milton, best known for his glorious descriptions of angels in *Paradise Lost* and *Paradise Regained*, described, in an early poem, Faeries visiting a newborn child:

Good luck befriend thee, Son; for at thy birth

The faery ladies danc'd upon the hearth:

Thy drowsy nurse hath sworn she did them spie

Come tripping to the room where thou didst lie;

And sweetly singing round thy bed

Strow all their blessings on thy sleeping head.

—JOHN MILTON, *VACATION EXERCISE AT COLLEGE*

AE, a plain and simple man who spoke about Faeries in crowded halls throughout the world, wrote in *The Candle of Vision*: "[There] was first a dazzle of light, then I saw that this came from the heart of a tall figure with a body apparently shaped out of half-transparent or opalescent air, and throughout the body ran a radiant, electrical fire, to which the heart seemed the centre. Around the head of this being and through its waving luminous hair . . . there appeared flaming wing-like auras." A talented artist, Russell also drew and painted what he saw.

William Sharp (1855–1905), who under this name was known as a successful journalist, also wrote under the pseudonym Fiona MacLeod. He seems to have been literally possessed by Faeries. After a strange encounter with a beautiful, luminous figure, he began to write wild plays and poetry about the Shining Ones, the ancient Faerie race of the Celts. Perhaps it was these beings who caused him to suffer bouts of mental illness toward the end of his life. Faeries are always dangerous.

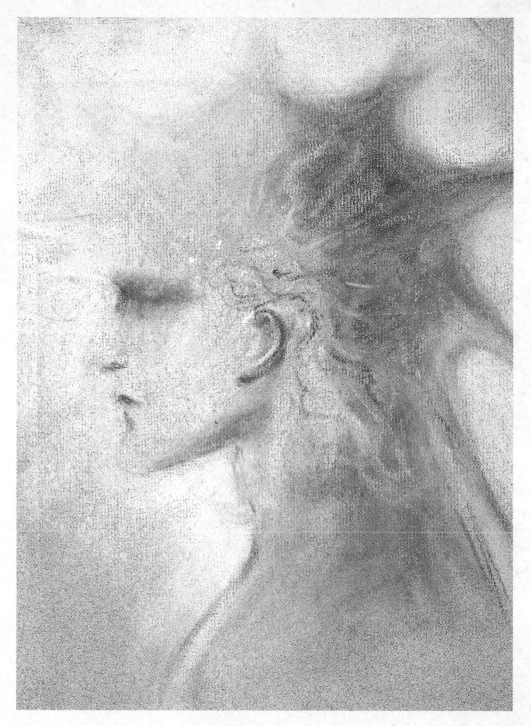

A prince of the Sidhe, noble and aloof, watches the actions of humanity with a world-weary look in this image by Irish writer and artist George William "AE" Russell (1867–1935).

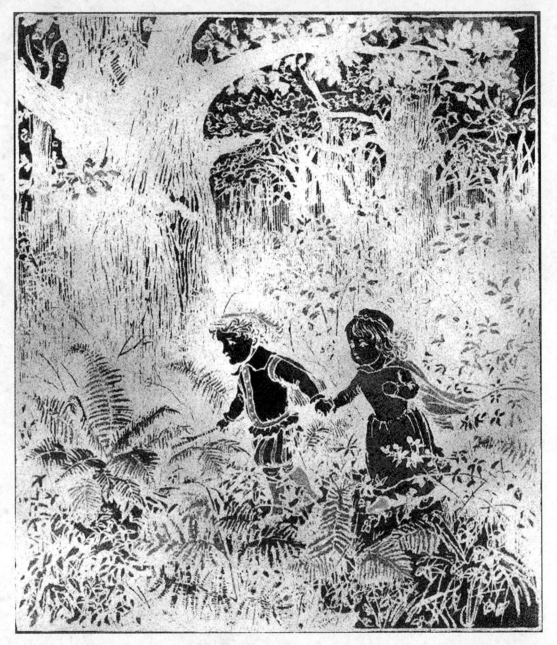

The mysterious Green Children emerged from a cave near the village of Woolpit, in Suffolk, England, during the reign of King Stephen (1135–1154). The children were widely regarded as being of Faerie origin. This drawing by Randolph Caldecott (1846–1886), which was manipulated by writer Brian Haughton, shows babes wandering lost in the woods, much as the Green Children would have done.

How beautiful they are,
The lordly ones
Who dwell in the hills,
In the hollow hills.

They have faces like flowers,
And their breath is wind
That blows over grass
Filled with dewy clover.

Their limbs are more white
Than shafts of moonshine:
They are more fleet
Than the March wind.

They laugh and are glad
And are terrible:
When their lances shake
Every green reed quivers.

How beautiful they are,
How beautiful
The lordly ones
In the hollow hills.

—FIONA MACLEOD, *THE IMMORTAL HOUR*

In Brittany the French man of letters the Vicomte Hersart de la Villemarqué (1815–1895), collected stories and poems from the Breton people, editing and crafting the literature into fantastic collections. Considered today as a romantic fabulator, nonetheless his writings show a wide knowledge of Faerie lore.

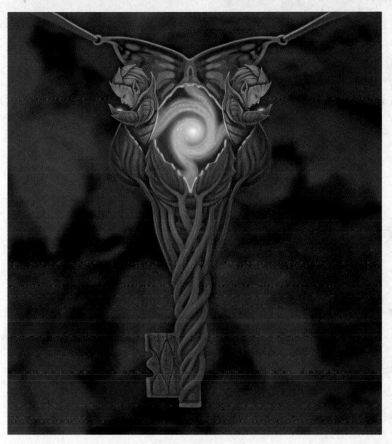

*The Key to Faerie,* by Matt Dangler.

One such story tells of a little tailor who was given the key to the Faerie realm. On entering, he found three piles of treasure: one gold, one silver, one copper. On each one sat a sheep of a different color. The tailor began to fill his pockets with gold, but the white sheep said, "Wouldn't you be able to carry more if you fetched a sack?" The tailor, delighted, ran off to get one. When he returned he could no longer find the way into the Faerie hill.

Once again, the Faeries had won.

Older, anonymous stories tell a different tale, as in the famous twelfth-century account of the Green Children, a boy

and a girl with green skin who emerged from a cave near the village of Woolpit, near Bury St Edmunds in England. Both were dressed in strange clothes made of unfamiliar material, and neither spoke English. Some have allowed them the status of extraterrestrials; others have thought they got their color from chemicals in the earth near the site of their discovery. But for many, the Green Children bore witness to the existence of Faeries, emerging from their strange underworld realm, unable to get home. The boy grew sick and died a few months after being found, but the girl apparently lived among humankind and gradually lost her green-tinged skin. She took the name Agnes Barre and married a senior ambassador to King Henry II.

> Their port was more than human, as they stood;
> I took it for a fairy vision
> Of some gay creatures of the element
> That in the colors of the rainbow live,
> And play i' th' plighted clouds. I was awe-struck,
> And as I passed I worshipped.

—JOHN MILTON, *COMUS*

Not all Faerie sightings are real. A few days before April 1, 2007, Dan Baines, a designer of illusions for stage magicians, posted on his Web site images claimed to be the mummified remains of a Faerie discovered by a dog walker on Firestone Hill in Derbyshire, England. Complete with hair, skin, ears, teeth and wings, the remains were claimed to "have been examined by anthropologists and forensic experts who can confirm the body is genuine" and photographed complete with a police evidence tag. According to the Web site, X-rays showed that the body was similar to that of a child, but the bones were "hollow like those of a bird making them particularly light."

The Web site on which the images appeared received more than 20,000 hits in one day, until Baines revealed he had created the corpse himself. He wrote: "Even if you believe in fairies, as I personally do, there will always have been an element of doubt in your mind that would suggest the remains are a hoax. However, the magic created by the possibility of the fairy being real is something you will remember for the rest of your life." Curiously, even after the corpse was revealed a fake, many people continued to believe in it—so strong is the desire to see and know Faeries.

Another possible fake is the famous San Pedro mummy. In 1971 a visiting anthropologist from the University of Wyoming was shown what appeared to be the mummified remains of a small man, supposedly found in the nearby San Pedro Mountains in 1932. Stories of Little People and legends of Faerie sightings abound in the area. Examination of the remains proved uncertain, and the jury is still out on the reality or otherwise of the San Pedro man.

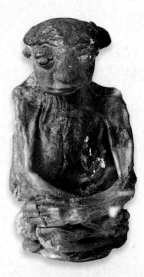

One of the most extraordinary accounts of Faerie sightings concerns one Anne Jefferies, the daughter of a poor laborer, who lived in the parish of St Teath in Cornwall. She

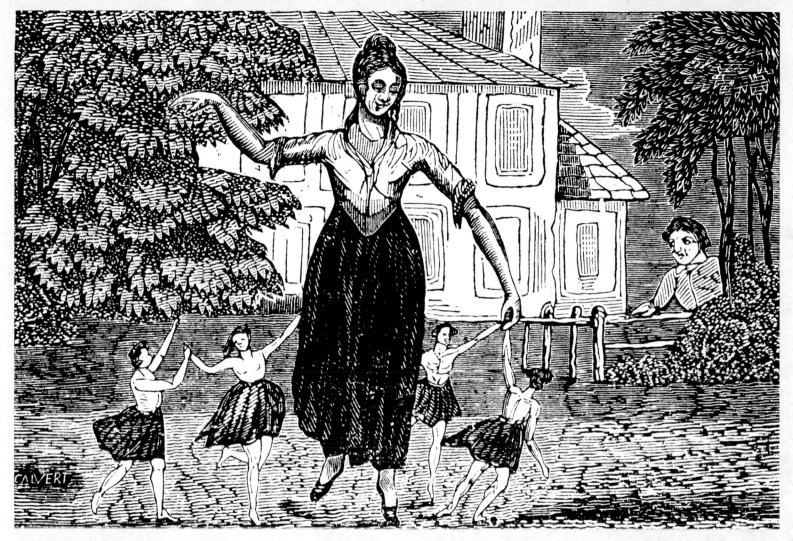

**OPPOSITE** Found in the San Pedro mountains, United States, a mummified body thought to be a Faerie, or a tiny man.

**ABOVE** Anne Jefferies always desired to see Faeries, and one day she did. This woodcut from the eighteenth century shows her dancing with a circle of Faeries outside her house.

was born in 1626 and died in 1698. Faeries were a regular topic of conversation, and Anne longed to see one for herself.

One day Anne, having finished her morning's work, was sitting in the arbor in her master's garden, when she heard a peculiar ringing sound and a very musical laugh. She perceived at the entrance of the arbor six little men, all clothed very handsomely in green. They were beautiful little figures, and had charming faces and bright eyes. The grandest of these little

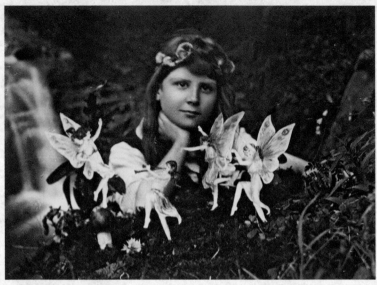

One of the photos of Faeries taken by Elsie Wright and Frances Griffiths in 1917.

visitors, who wore a red feather in his cap, advanced in front the others, and, making a most polite bow to Anne, addressed her familiarly in the kindest words.

Presently he called his companions and one of them ran his fingers over her eyes, and Anne became blind, and felt herself whirled through the air at a great rate. By and by, one of her little companions said something, and lo! Anne had her sight at once restored. She was in the most beautiful of places—temples and palaces of gold and silver, trees laden with fruits and flowers, lakes full of gold and silver fish and the air full of birds of the sweetest song. Ladies and gentlemen were walking about while others idled in the most luxurious bowers. Still more were dancing, while others engaged in sports of various kinds. Anne was, however, surprised to find that these happy people were no longer the small people she had previously seen. There was now no more than the difference usually seen in a crowd, between their height and her own.

Anne was constantly attended by her six friends; but the finest gentleman, who was the first to address her, continued her favorite, at which the others appeared to be very jealous. Eventually Anne and her companion contrived to separate themselves, and they retired into some most lovely gardens, where they were hidden by the luxuriance of the flowers.

Sweetly did they pass the time, and Anne desired that this should continue forever. However, when they were at the happiest, there was heard a great noise, and presently five other Faeries at the head of a crowd came after them in a violent rage. Her companion drew his sword to defend her, but he was soon beaten down and lay wounded at her feet.

The Faerie who had blinded her again placed his hands upon her eyes, and all was dark. She heard strange noises, as if a thousand flies were buzzing around her, and felt herself whirled about and about. Finally, she awoke to find herself surrounded by anxious friends to whom she seemed only to have fallen into a swoon. To the end of her days she told this tale and many believed that she had been visited by Faeries.

—Adapted from the original report of Robert Hunt in his book *Popular Romances of the West of England*

## Faerie Photos

In July 1917, in the little West Yorkshire village of Cottingley, two young English girls, Elsie Wright and Frances Griffiths, claimed to have taken some photographs of Faeries in a secret

dell by Cottingley Beck. At first their parents thought they were making it up, but when the photographs were developed, they were amazed to see tiny winged shapes apparently flitting around the girls. A photographic expert was called in, and after a careful examination of the photos declared he could find no evidence of trickery. Amid great excitement, the photos were declared genuine.

When the photographs were published three years later they sparked off a debate that caused people to take sides over the existence or non-existence of Faeries. No lesser person than Sir Arthur Conan Doyle (1859–1930) heard of the Faerie photos and visited the girls in 1920. He too declared them genuine. Controversy raged on, with eminent experts arguing for and against the veracity of the photos. Hundreds of people flocked to Cottingley and some claimed to have seen Faeries themselves. Years later, Elsie Wright, by then a grandmother, declared that the photos were faked, but that she really had seen Faeries even though they were not the ones in the photos.

In a letter originally written in 1917 by Frances Griffiths to a friend in Cape Town, South Africa, a photo was included that was taken two years before the public sensation. Frances wrote: "I am sending you two photos, both of me. One is of me in a bathing costume in our backyard. Uncle Arthur took that, while the other is of me with some fairies up the beck. Elsie took that one."

Soon after the Cottingley photos appeared, another English girl, Dorothy Inman, produced Faerie photos of a similar kind. A few years later in Germany a girl named Else Arnhem took several more, which she later published. The question in all these instances is: if the photos were faked, how was it done? In the case of the Cottingley photos, although they were subjected to intense scrutiny, the means by which they were created was never discovered, in an age years before computer manipulation. Neither Elsie nor Frances gave away the secret, and both Dorothy Inman and Else Arnhem died without revealing how they had created their photos.

# HOUSEHOLD FAERIES

NOT ALL FAERIES ARE MALICIOUS AND WILD, though even the kindest are given to playing tricks. Known as Brownies throughout most of England, the helpful Faeries are Bwcas in Wales, Bodachs in the Highlands of Scotland, Lobs and Hobs in Cornwall. There are so many stories of these creatures, taken so completely for granted, they are as real as any human being.

Most are kindly Faeries that help out around the home, especially on farms and country places, carrying out the tasks the busy wife is too tired to do. Repaid with a bowl of milk or a knob of butter, the Hob or Lob or the Brownie will sweep, clean, wash up and remake the fire, look after the sheep, guard the hens and even give good advice as needed. He usually sleeps in a hidden corner or up the chimney. His reasons for doing this are unknown—maybe simple kindness or a kind of symbiosis with human beings.

The Brownie is permitted certain treats: the most loved of which seems to be Knuckled Cakes, made of meal still warm from the mill, toasted over the embers of the fire on a

**ABOVE** A Brownie carries a hot dish of coals to warm the beds of his human hosts.

**OPPOSITE** This curious Faerie, painted by Arthur Rackham (1867–1939), is a type of Brownie. The Faerie is shown here as a handsome tree spirit who seems to be more than a little enamored of the young lady in his care.

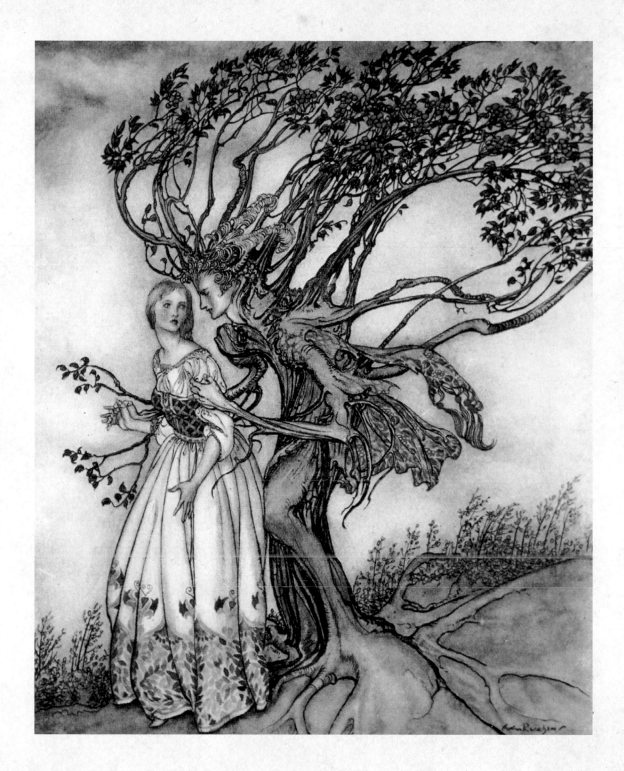

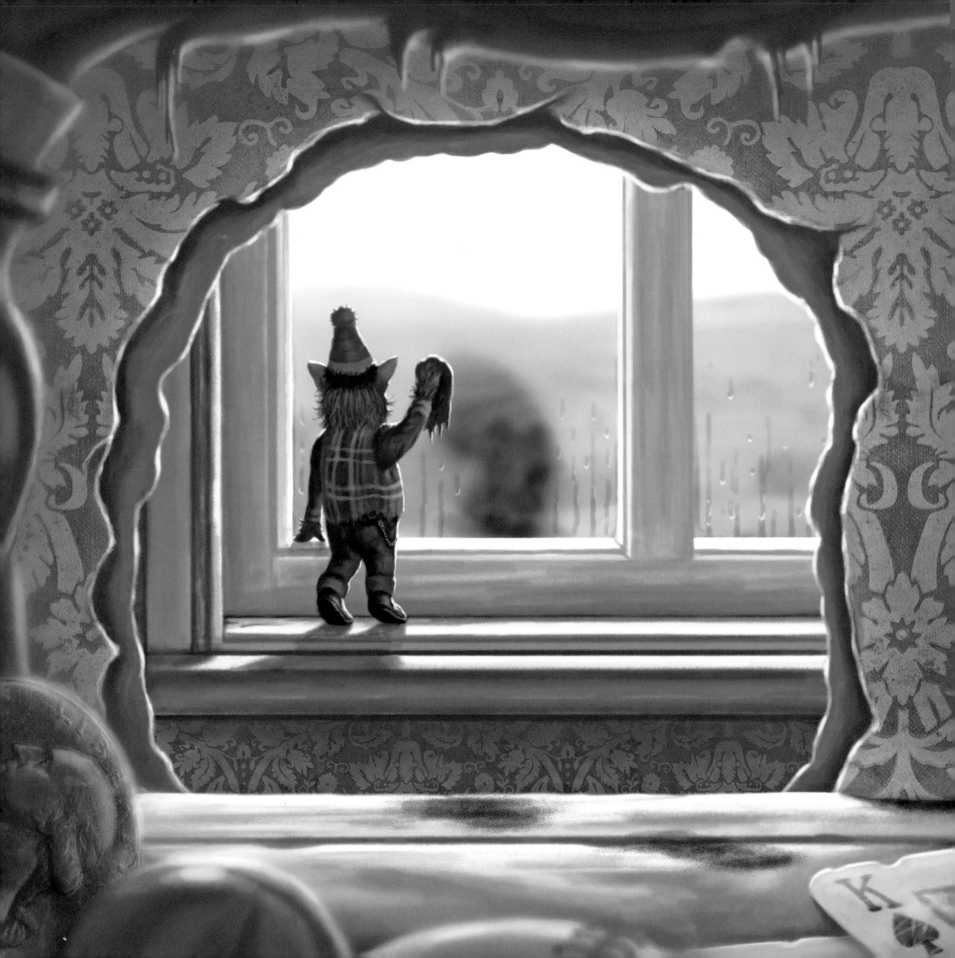

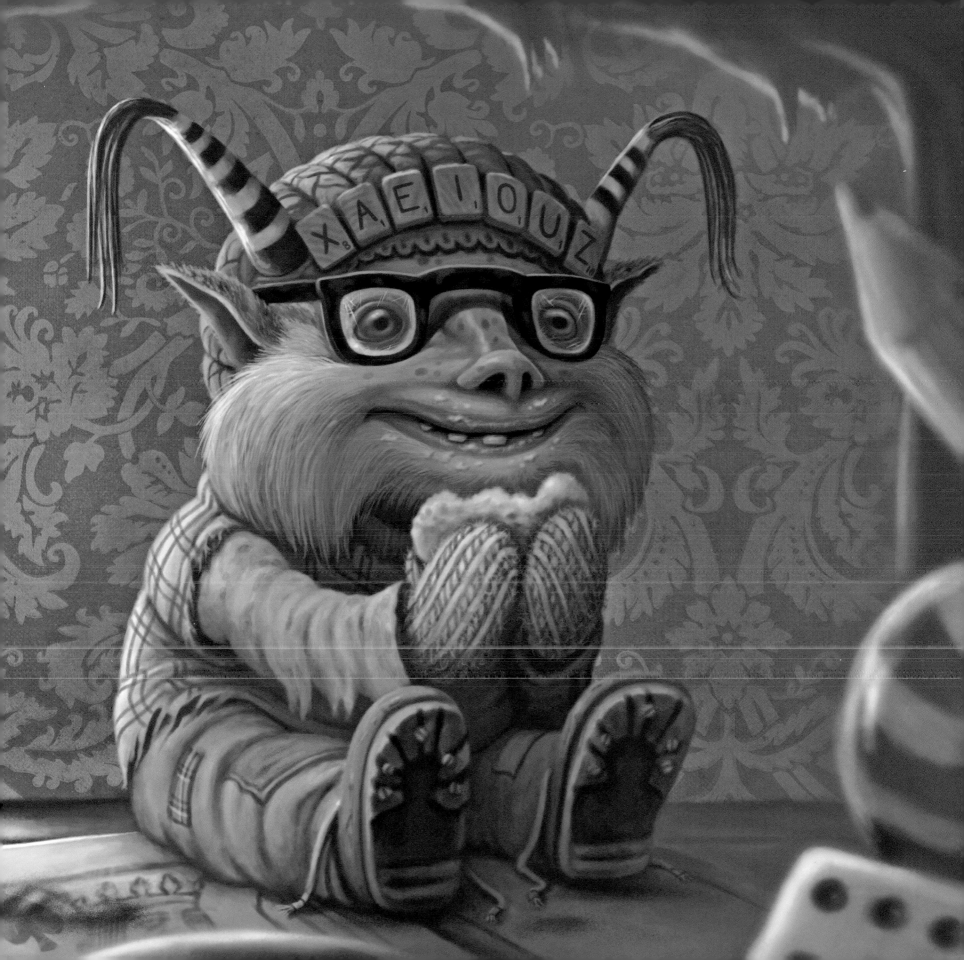

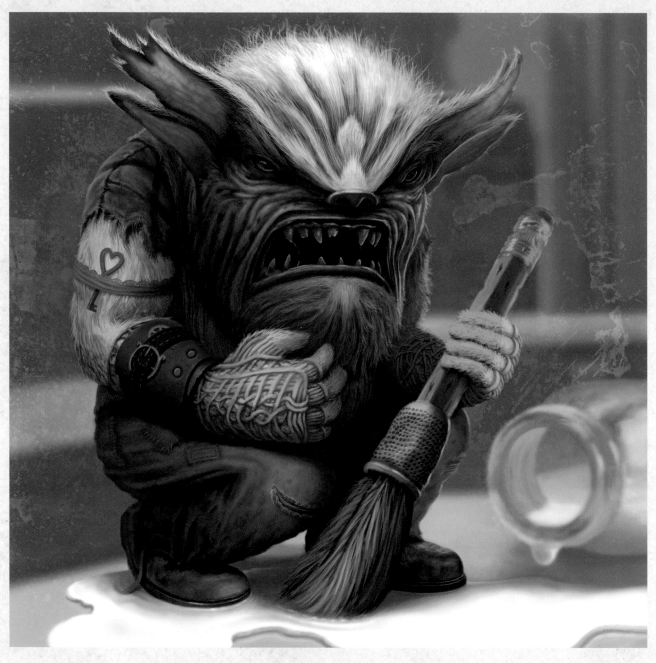

PREVIOUS SPREAD Safe in his own small corner of the house, a Brownie wolfs down a knuckled cake before going back to work. Painting by Matt Dangler.

ABOVE An angry Boggart is looking for trouble in this painting by Matt Dangler.

griddle pan and spread with honey. The housewife prepares these and leaves them where the Brownie is sure to find them. When a tidbit is given to a child, parents still say: "There's a piece would please a Brownie."

## KNUCKLED CAKES

Ingredients:
1½ cups of self-rising flour
3 ounces shortening or fat
a pinch of salt
½ cup currants
1 large egg
½ cup runny honey
a little milk for binding

Rub shortening or fat into the flour, and add salt and currants. Bind together with honey, egg and enough milk to make soft dough. Heat a griddle or large frying pan on stovetop to medium temperature. Use a little melted fat for each batch of cakes. Flour both hands, and lift one dessert spoon of mixture onto one palm, then shape between palms to a rough oval. Punch the top of each cake with floured knuckles and cook in small batches on the griddle until cakes set, rise and brown, turning them once.

Warning: Faeries hate burned cakes!

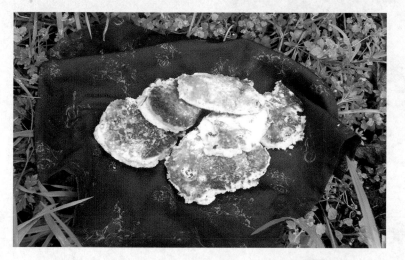

Knuckled cakes made ready for an offering to the Hidden Ones.

It is never a good thing to see a household Faerie—better to behave as if they are not there. Giving them good clothing is also a bad idea, as it makes them more temperamental or may even cause them to leave the household. Angry Brownies can turn into Boggarts, their kindness turning to malice and their helpfulness to hindrance.

An industrious Brownie from Cranshaws in Berwickshire regularly threshed the corn and transported it into the barn before rain spoiled it, until someone remarked that the harvest was not as well done that year as it had been in years before. The Brownie was so angry that he took the entire harvest to nearby Raven Crag and threw it off the cliff. One challenges the skills of such magical helpers at one's peril.

It's not well mowed! It's not well mowed!
Then it's never mowed by me again!
I'll scatter it over the Raven stone
And they'll have some work e're it's mowed again!

—KATHERINE BRIGGS, *A DICTIONARY OF FAIRIES*

# FAERIE GOLD

FAERIES ARE LONG ASSOCIATED WITH RICHES, though their gifts may be of another kind than gold: good luck, visions, healthy cattle and crops. Stories abound of their guarding vast hoards of wealth, as in the man who went into a Faerie hill in Ireland and, moving from cave to cave, found mounds of gems carefully sorted into types—diamonds in one room, rubies in another, emeralds, topaz, pearls and sapphires. When he tried to carry some of the jewels off, he was terrified by the roaring of a great voice and dropped his spoils and ran away, never to return to that place again.

The medieval author Giraldus Cambrensis traveled through Wales in 1188 and wrote about it in his book *Itinerarium Cambriae*. He described how a boy named Elidor found his way into a realm beneath the earth, where there were fields and rivers, woods and meadows, but neither sun nor moon shone so that the only illumination was a dim grey light. There, he found a Faerie court with its king and courtiers and subjects, all with long silken yellow hair. Welcomed there, Elidor afterward came and went at will, until he

desired to bring back a gift for his mother. While playing with the Faerie king's son, he stole a golden ball and ran home, pursued by angry guards. As he reached the threshold of his home, he tripped and the ball flew from his hands, to be caught and carried off by his pursuers, who spat on him as they passed. Thereafter, Elidor was never able to find the

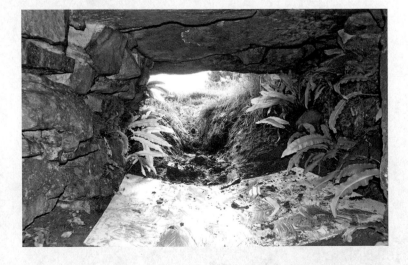

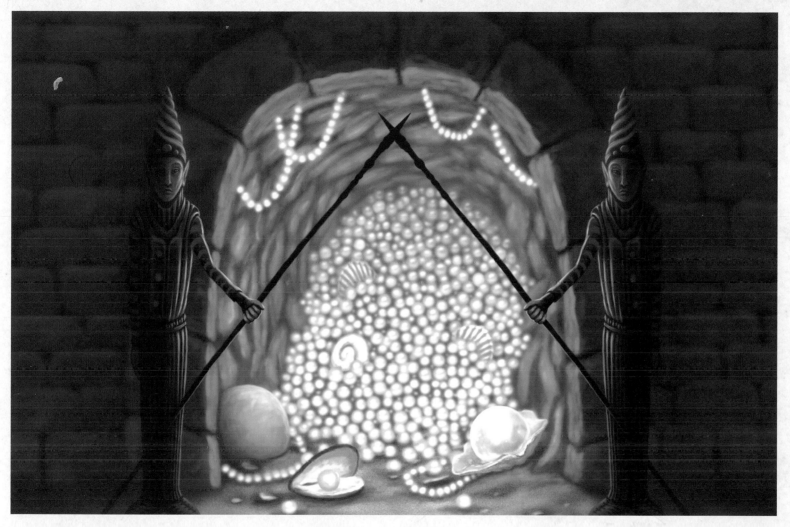

OPPOSITE This entrance to the Otherworld, known as the Cave of the Cats, lies at Rathcroghan in Ireland. It opens on All Hallows Eve to allow entrance to the Faerie world.

ABOVE *Guardians of Faerie Gold*, by Matt Dangler.

way back into the Faerie world, though he afterward became famous for his tales of the place. He even remembered words in the Faerie tongue which he related to old Giraldus: *Udor udorum* meant "bring water" and *Halgein udorum*, "bring salt," though these words sound more like Latin or Greek than the language of Faerie.

Elidor also reported that "They were of small stature, but well proportioned and had horses proportioned to themselves. They ate neither flesh nor fish, but lived on a diet of milk and a porridge flavoured with saffron. They never took an oath, for they despised nothing so much as lies and a strict reverence for truth."

# FAERIE CHILDREN

FAERIES ARE SAID TO give birth only rarely, and their children are pale and sickly, the reason unknown. Perhaps this is one of the reasons Faeries go in search of human children, stealing them away. In their stead, they will leave a hungry copy, like a reflection in a mirror, which soon after will die as if by natural causes. Those with the gift of second sight can see these changelings, wrinkled and angry, ever wailing and screaming for food. Others say the changelings are not living at all, but wooden stumps shaped roughly into human form and given the semblance of life by Faerie glamour. The human children are almost never seen or heard from again, and while some might say they are better off in the Faerie realm, others hint darkly of slavery and unkindness.

Sometimes women are taken to help deliver Faerie children. One story tells how a midwife was woken late one night by a knocking at the door, and when she answered it she found a tall, dark man outside who begged her to come and attend to his wife, who was about to give birth. The woman climbed onto the man's horse and went with him to a fine

castle filled with rich tapestries and treasures. And there, she helped the woman of the house, who was as beautiful as the day is long, through her time of travail. When a fine son was born to her, the man entered the room and gave the midwife

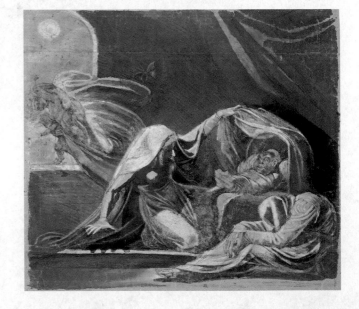

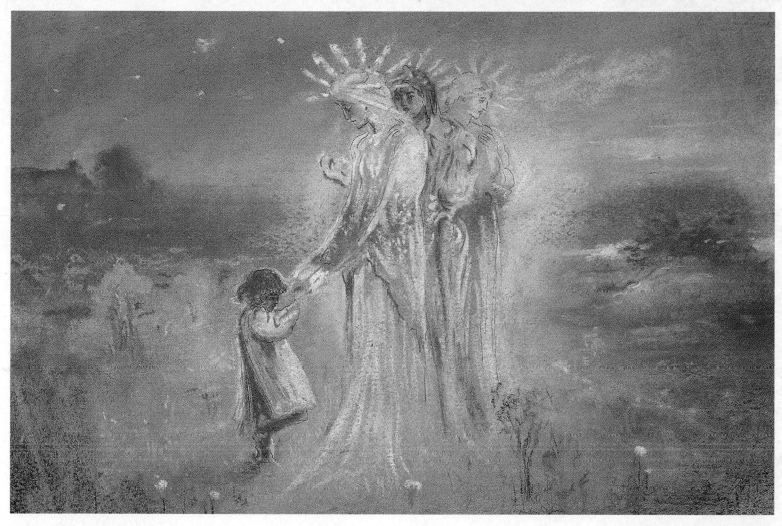

OPPOSITE In this unsettling image by Henry Fuseli, who spent the last years of his life in an insane asylum, a Faerie steals a child while the child's mother sleeps.

ABOVE The mighty Sidhe look down upon the frail human child that has been brought to them in this picture by the nineteenth-century Irish visionary Æ.

a vessel of green ointment with which to anoint him. But the woman had an itch in her right eye, and in rubbing it got some of the ointment into it. At once she could see through the fateful eye that the fine castle was only a damp cave, and that the man, his wife and their child, were pale and thin with ragged clothes.

The woman said nothing, and the man took her home and paid her in gold. But soon after, she saw him in the marketplace and could not forbear from greeting him. When he saw that she could see him, he struck the eye she had touched with the Faerie ointment, so that thereafter she was blind in that eye and never again saw any of the Faerie kind.

# FAERIE MEDICINE AND GOOD FORTUNE

STORIES OF FAERIE HEALING ABOUND. Faerie ointment gives the human user the ability to see the Faeries that normally pass unseen amongst us. Anything touched by a Faerie, or previously owned or blessed by one, can bring healing and good luck.

One old tale relates how a man accidentally strayed into a Faerie howe, one of the hollow green mounds where the folk live. Inside, the mound seemed to him like a splendid house, full of bright light and merriment. He was made welcome and offered a cup full of fine wine, but being mindful of the law against drinking any Faerie brew, he secretly poured the drink away and hid the cup beneath his coat. Soon after the Faeries noted that he neither ate nor drank and drove him away. But he kept the cup and gave it to the king of Scotland, in whose treasury it remained for many years, until it vanished as suddenly as it had appeared. It is said that any who drank from it would be healed of whatever ailed them, and that they remained youthful far longer than normal man or woman.

Three of the herbs used by healers in the small Welsh village of Myddfai: (left) barberry, (middle) betony, (right) clover. Herbal remedies of this kind have been used for centuries, but the cures of the village are one of the few instances where they are described as Faerie taught.

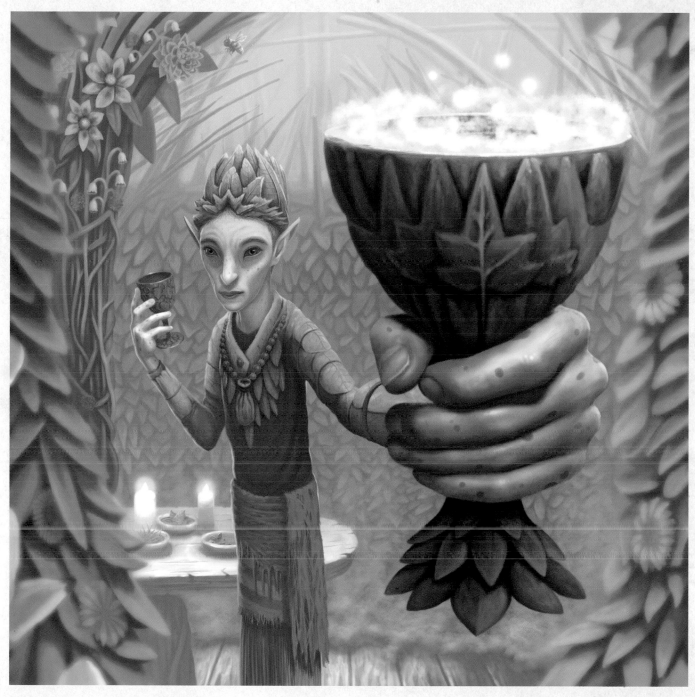

*The Faerie Cupbearer*, by Matt Dangler.

Certain families were said to have learned their healing gifts from Faeries, and many passed the secrets from father to son or mother to daughter for hundreds of years. Such was the secrecy surrounding these cures, which were often effective, that little is known of them to this day. The most famous of these families are the Physicians of Myddfai, a Welsh family whose descendants carried healing wisdom through several generations. They are said to be descended from the marriage of a mortal and a Faerie known as the Lady of Llyn y Fan Fach. She came out of a lake with a string of magical cows to marry her mortal man, only to return after he broke a magical prohibition from striking her three times. In each case, the blows were kindly and unintentional, but the agreement held firm, and the lady vanished, leaving her grieving husband with three children, whose descendants became the renowned physicians.

The same Anne Jefferies referred to earlier, who was romanced by a Faerie, afterward became a great healer. A manuscript in the Bodleian Library, Oxford, dated 1647, describes "a young girl who foretells things to come . . . most of which have fallen out to be true. She eats nothing but sweetmeats . . . which are brought to her by small people clad in green and sometimes by birds. She cures most diseases, the Falling Sickness especially and broken bones, only with the touch of her hands."

Scottish tradition tells of a Faerie flag owned by the chieftains of the MacDonald clan, which had its own healing properties. A gift from the Faeries to a young chieftain, or from a departing Faerie lover, the flag is kept at Dunvegan Castle. Its magical properties include the ability to heal wounds received in battle, to give strength to sick members of the clan, to cure sickness in cattle and even to increase fertility. Made of silk, the flag is yellow-brown in color and measures about eighteen inches square. Time has not been kind to this fabulous relic, and it is somewhat tattered and fragile these days. As recently as the twentieth century the flag was said to have extinguished a fire at the castle, and to have brought luck to servicemen flying bombing missions during World War II.

*The Faerie Flag* as imagined by Matt Dangler.

## FAERIE OINTMENT

Ingredients:
sweet salad oil
rose and marigold water (made from flowers to
    be gathered while facing east)

The next five ingredients must be gathered near
a hill where Faeries are known to go:
marigold buds
hollyhock buds
wild thyme buds
young hazel buds
grass (fresh cut from a hill's Faerie throne)

Place sweet salad oil into a glass vial that has
been washed in rose and marigold water. Wash
the oil till it turns white, and put it into a glass.
Add the marigold buds, the hollyhock buds, the
tops of new wild thyme buds, and young hazel
buds. Then, on a Faerie hill, seek out a Faerie
throne, a place where they sit, and take from it a
cutting of grass. Then put all of this into the oil
and pour that oil into a fresh vial and leave it to
dissolve in the sun for three days, after which,
if you breath in the scent of the brew, you shall
see Faeries.

# FAERIE MUSIC

THE FAERIES ARE FAMOUS LOVERS and makers of music, and there are countless stories of humans hearing the strains of their music at night as they wander home. Sometimes, if the Faeries needed a musician to provide merriment and had none of their own, they would steal away a human fiddler and command him to play all night, until his bow wore out or his arm could move no more. Often they would pay him in gold pieces, but as with so many things Faerie, these were mere illusion and turned to leaves in the light of day.

The visionary Irish writer Ella Young (1867–1956) wrote in her diary for August 27, 1917:

> I woke to hear wonderful music . . . It came [on] like slow-moving waves. On the crest of each wave there was a running melody, and as spray curling on a wave-top takes one's eye this caught one's ear [ . . . ] this was the most wonderful and beautiful

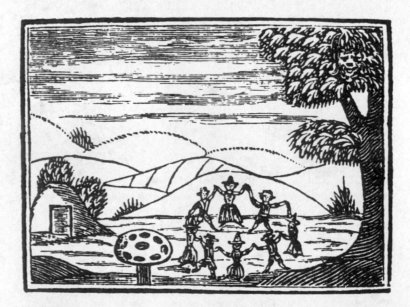

ABOVE Faeries dance in a ring in this ca. seventeenth-century woodcut.

OPPOSITE The Faerie love of music is in full swing in *The Concert* by John Anster Fitzgerald.

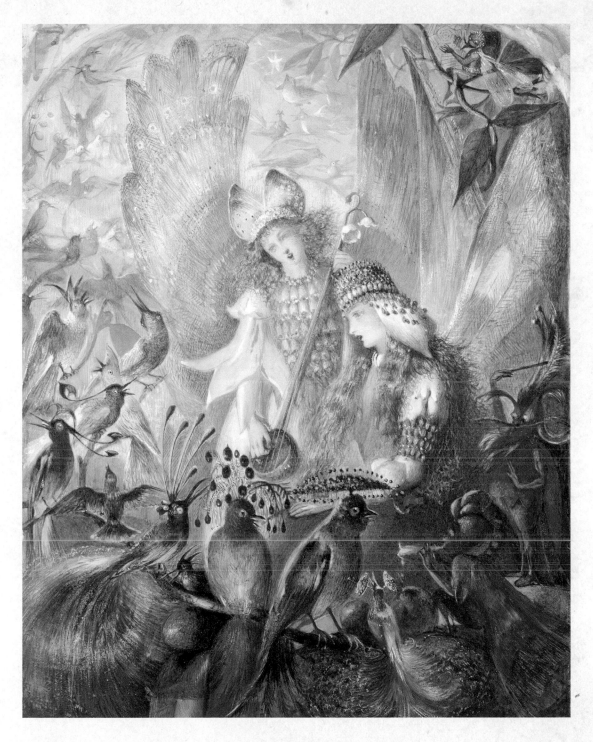

music of the Sidhe that I have ever heard. I woke later in the night out of a dream because I heard [. . .] Voices as of two people calling out questions and replies to each other as they walked . . . the men passed close under my window, one of them singing a snatch of an air in a high lilting voice. It was only when I wakened more fully that I knew they could not be mortals.

Faerie music enchants like the singing of the Birds of Rhiannon in Celtic lore that put those who heard them into a strange half-waking state lasting for years. The eighth century Irish voyager Bran mac Febal was drawn out of his hall by the singing of a Faerie woman and the chiming of bells on a silver branch, which she carried. He embarked on a voyage to the West which led him to the Faerie Isles. The story gives a wonderful picture of a Faerie realm:

Crystal and silver
The branch that to you I show:
'Tis from a wondrous isle—
Distant seas close it;
Glistening around it
The sea-horses hie them:

They who that island near
Mark a stone standing:
From it a music comes,
Unheard-of, enchanting.
They who that music hear
In clear tones answer—
Hosts sing in choruses
To its arising.

A folk that through ages long
Know no decaying,
No death nor sickness, nor
A voice raised in wailing.
Such games they play there—
Coracle on wave-ways
*With chariot on land contends—*
*How swift the race is!*

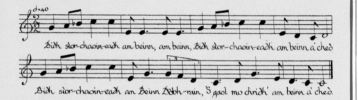
This strange and enchanting snatch of song was collected in the islands of Scotland in the early twentieth century. It is one of many that refer to the loss of a child, stolen away by Faeries, whose wailing voice can be heard on the wind.

## CRODH CHAILEIN

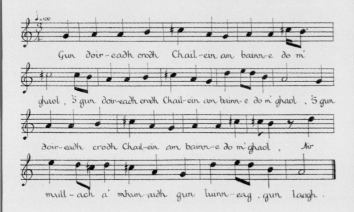

Gun doir-eadh crodh Chail-ein am bainn-e do m'

ghaol, 's gun doir-eadh crodh Chail-ein am bainn-e do m' ghaol, 's gun

doir-eadh crodh Chail-ein am bainn-e do m' ghaol. Air

mull-ach a' mhun-aidh gun tuinn-eag, gun laugh.

*Translation*

## COLIN'S CATTLE

Colin's cattle would give their milk
to my beloved
On the top of the moor without milking
song or calf.
Brindled, speckled, spotted cattle,
the color of the grouse,
Cattle that fill milk pails and rear their calves
The cattle of Colin, son of Conn
Collin's cattle would give milk to the heather.

This mysterious song, said to be of Faerie origin, was sung to the deer that are the cattle of Faeryland. On hearing this song they become passive and may be milked by the Faerie people. The second line refers to the fact that many cows will not give milk unless sung to and accompanied by their calves.

## The Dangers Of Dancing

Faeries often use music and song to draw human folk to them. From Islamic folklore we hear the story of young Hussein, who was walking home one evening through a twilit valley. First, he heard a distant strain of music, and then he saw figures gathered around a fire, clapping and dancing to the sounds of a rebab played by an old man. As he drew nearer, Hussein recognized the faces of friends he knew well, and one called out to him: "Hussein, come, we have been waiting for you." Hussein joined in the dancing, and hours passed under the spell of the moon and the wild music. Then, as dawn approached, Hussein happened to glance down and saw, to his horror, that the feet of all the other dancers were on backward, and that their eyes were hollow and empty. "These are Djinn!" cried Hussein in terror, and at once he found himself alone, the last notes of the rebab dying away in the morning light. Hussein stumbled back home and lay sick in bed for many weeks after. Both he and his family blamed the Djinn.

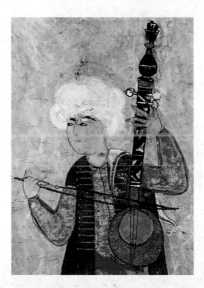

The Persian rebab is a very ancient instrument played with a bow. Its origins are not clear; perhaps it could be of Faerie design and influence?

# CROSSING THE BORDER

FAERIES. Half glimpsed in the shadows, their stories interwoven with ours, threading our dreams. They have been here for as long as we remember, and will be here for as long as we are—most likely longer; for they are, on their own admission, a long-lived race. Our worlds are aligned, separate but contiguous. A veil separates us, but there are times when it parts. Then, be you so lucky or unlucky, you may cross the border into Faeryland. And of course, Faeries may choose to cross into our world, bringing magic and wonder with them. Whether or not you choose to believe in them, be on the alert—because you never know when you might see one. Faeries *are* there. And they perceive you.

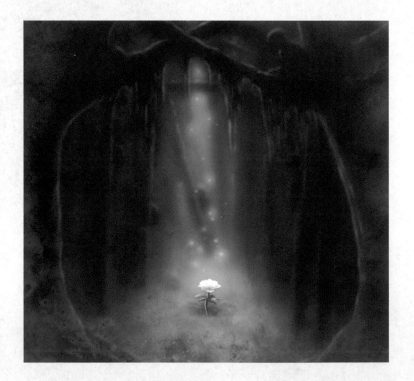

*The Haunted Wood*, by Matt Dangler.

# BIBLIOGRAPHY
# AND FURTHER READING

## More About Faeries

Briggs, Katherine. *A Dictionary of Fairies*. London: Allen Lane, 1976.

Keightley, Thomas. *The Fairy Mythology*. London: Wildwood House. 1981.

Kirk, Robert. *The Secret Commonwealth of Elves, Fauns and Fairies*. New York, New York Review of Books, 2007.

McDermott, Kristen. "Winter Fool, Summer Queen: Shakespeare's Folklore and the English Holiday Cycle." The Endicott Studio, accessed April 2012. http://www.endicott-studio.com/jMA03Summer/shakespeare.html/.

Matthews, John. *Classic Celtic Fairy Tales*. London: Blandford, 1999.

————. *Tales of the Celtic Otherworld*. London: Blandford, 1998.

Matthews, John, and Caitlin Matthews. *A Fairy Tale Reader*. London: Aquarian Press, 1993.

————. *StoryWorld: Fairy Magic*. Dorking: Templar Books, 2011.

Mynne, Hugh. *The Faerie Way*. St Paul, Minn.: Llewellyn Publications, 1996.

Narvaez, Peter, ed. *The Good People*. Lexington, Ky.: University of Kentucky Press, 1999.

Ralls-MacLeod, Karen. *Music and the Celtic Otherworld*. Edinburgh: Polygon, 2000.

Skelton, Robin, and Margaret Blackwood, eds. *Earth, Air, Fire, Water*. London: Arkana Books, 1990.

Stewart, R. J. *The Living World of Faery*. Glastonbury: Gothic Image, 1995.

## Web Sites

SurLaLune
www.surlalunefairytales.com
A wonderful gallery of Faerie art and books

World of Froud
www.worldoffroud.com
The web site of the premier Faerie artists

Faerieworlds
www.faerieworlds.com
The place where Faeries are everything

## Magazines

*Faerie Magazine*
www.faeriemagazine.com
U.S. magazine with everything you ever need to know about Faeries and those who celebrate them

*The Magical Times*
www.themagicaltimes.com
U.K. magazine with news and articles on all things Faerie

# ACKNOWLEDGMENTS

Special thanks to Caitlín for preparing the recipe for Knuckled Cakes and for supplying the music for the Faerie songs; to Brian and Wendy Froud for enthusiastic encouragement; to Ari Berk for advice about Little People; and to the wonderful staff of *Faerie Magazine* for being there, and for looking after a weary traveler in 2011.

# ILLUSTRATION CREDITS

All artworks by Matt Dangler created specially for this book are credited in the caption © 2013 Matt Dangler. Background textures by Caleb Kimbrough and Dustin Schmieding courtesy of Bittbox.com. **Page 1:** *The Topsie Turvies* copyright © Brian Froud. Used with permission of the artist. **Page 2:** *Faeries Looking Through a Gothic Arch*, John Anster Fitzgerald, ca. 1864. Watercolor with gouache, 17.7 x 26.6 cm. Private collection. Photograph © The Maas Gallery, London. The Bridgeman Art Library. **Page 8:** *Scaleber Force*. Photograph © Steve Liptrot, Dreamstime.com. **Page 11:** *The Changeling*, by John Bauer, ca. 1913. Watercolor, 25.2 x 25.2 cm. **Page 12:** *Queen Mab's Cave*, by Joseph Mallord William Turner, ca. 1846. Oil on canvas, 92.1 x 122.6 cm. © Tate, London 2011. **Page 13:** *Take the Fair Face of Woman, and Gently Suspending, With Butterflies, Flowers, and Jewels Attending, Thus Your Fairy is Made of Most Beautiful Things*, by Sophie Anderson (1823–1903). Oil on Canvas, 53.3 x 43.1 cm. Private collection. Photograph © The Maas Gallery, London. The Bridgeman Art Library. **Page 15:** *The Quarrel of Oberon and Titania*, by Sir Joseph Noel Paton, 1849. Oil on canvas, 99 x 152 cm. Scottish National Gallery, Edinburgh, Scotland. **Page 16:** *The Riders of the Sidhe*, 1911. Tempera on canvas. The McManus: Dundee's Art Gallery and Museum, Dundee, Scotland. **Page 17:** *Faery Mab*, by Henry Fuseli, ca. 1815–1820. Oil on canvas, 70 x 90.8 cm. By permission of the Folger Shakespeare Library, Washington, D.C. **Page 19:** *Puck*, by Sir Joshua Reynolds, 1789. Oil on canvas, 102 x 81 cm. Private collection. The Bridgeman Art Library. **Page 20, Right:** *The Selkies*, by Virginia Lee. Author's collection via *StoryWorld: Legends of the Sea* by John and Caitlin Matthews. © Templar Publishing. **Page 21:** *La Peri (Mythological Subject)*, by Gustave Moreau, 1865. Graphite, ink, gray wash, gold metallic paint, and white gouache on cream wove tracing paper, laid down on ivory wove paper, 35.7 x 25.5 cm. Paintings and Drawings Department, Art Institute of Chicago, Chicago, IL. **Page 22:** *Fisherman and Djin*, by Adalbert Stieren, ca. 1920. Illustration from *Tausend und eine nacht*. **Page 23:** *Flying genie or, Apsaras, from Dunhuang, Gansu Province*, ca. ninth to tenth centuries. Paint on silk. **Page 27:** *Oberon, Titania and Puck with Fairies Dancing*, by William Blake, ca. 1786. Graphite and watercolor on paper, 47.5 x 67.5 cm. © Tate, London 2011. **Page 29:** *Faeries in a Bird's Nest*,

by John Anster Fitzgerald. Oil on canvas, 25 x 30.5 cm. Private collection. Photo © The Maas Gallery, London. The Bridgeman Art Library. **Page 32:** *Glastonbury Tor*. Photograph. Fortean Picture Library. **Page 33:** *The Release of Ariel*, by John Anster Fitzgerald. Oil on canvas. **Page 34, Top:** *Doon Hill*, Aberfoyle. Photograph. Fortean Picture Library. **Page 34, Bottom:** *Craig y Dinas, Wales*. Photograph. Fortean Picture Library. **Page 35, Left:** *Athgreany Stone Circle: The Pipers*. Photograph. **Page 35, Top:** *A Faery Thorn Tree*. Photograph. **Page 37:** *A Warrior of the Sidhe*, by AE. Oil on canvas. Ulster Museum, Belfast, Northern Ireland. **Page 38:** *The Green Children*, original illustration by Randolph Caldecott (1846–1886), manipulated by Brian Haughton. Used with permission of the artist. **Page 40:** *Mummified little man found in the San Pedro Mountains*, USA. Photograph. Fortean Picture Library. **Page 41:** *Ann Jefferies and Fairies*, 1645. Woodcut. **Page 42:** *Alice and the Fairies*, by Elsie Wright, 1917. Photograph. © NMPFT/Glenn Hill. Science & Society Picture Library. All rights reserved. **Page 44:** *Ukobach*, by M. L. Breton, 1863. Woodblock. From *Le Dictionnaire Infernel* by Collin de Plancy. Division of Rare and Manuscript Collections, Cornell University, Ithaca, NY. **Page 45:** *The Three Wishes*, by Arthur Rackham, ca. 1909. Pen, ink, and watercolor on paper. From *Spring in the Snow and Other Tales of the Good Old Times*. The Art Archive, Kharbine-Tapabo, Art Resource, NY. **Page 49:** *Knuckled Cakes*. Photograph. Author's collection. **Page 50:** *Rathcroghan Cave*, 2012. Photograph. Courtesy Rathcroghan Visitor Centre, Cruachan Aí Heritage Centre, Tulsk, Co. Roscommon, Ireland. **Page 52:** *The Changeling*, 1780. Black chalk and watercolor on paper, 48 x 53 cm. © 2012 Kunsthaus Zürich. All rights reserved. **Page 53:** *The Stolen Child*, by AE. Oil on canvas. Ulster Museum, Belfast, Northern Ireland. **Page 54, Left:** *Barberis vulgaris*. Photograph. © Eugene Shapovalov, Dreamstime.com. **Page 54, Center:** *Purple Bettony (Betonica officinalis)*. Photograph. © Rbiedermann, Dreamstime.com. **Page 54, Right:** *Clover*. Photograph. © Jolanta Dabrowska, Dreamstime.com. **Page 58:** *Faeries Dancing in a Ring*, ca. seventeenth century. Woodcut. Fortean Picture Library. **Page 59:** *The Concert*, by John Anster Fitzgerald. Watercolor on paper, 25.3 x 19 cm. Private collection. Photograph © Peter Nahum at The Leicester Galleries, London. The Bridgeman Art Library. **Page 61:** *Persian Rebab*, ca. 1911.